Dear Sara

Thanks to your generosity,
NRDC is better able to stop places like this
from happening

[signature]

the day after tomorrow
images of our earth in crisis

by J Henry Fair

with essays by
James Hansen
Allen Hershkowitz
Jack Hitt
Roger D. Hodge
Frances Mayes
John Rockwell
Tensie Whelan

pH powerHouse Books Brooklyn, NY

Baton Rouge, Louisiana.
Aerators violently agitate the waste from
a pulp mill, turning the liquid to a foam,
which makes patterns on the surface. This
plant manufactures popular brands of paper
towels and printer paper.

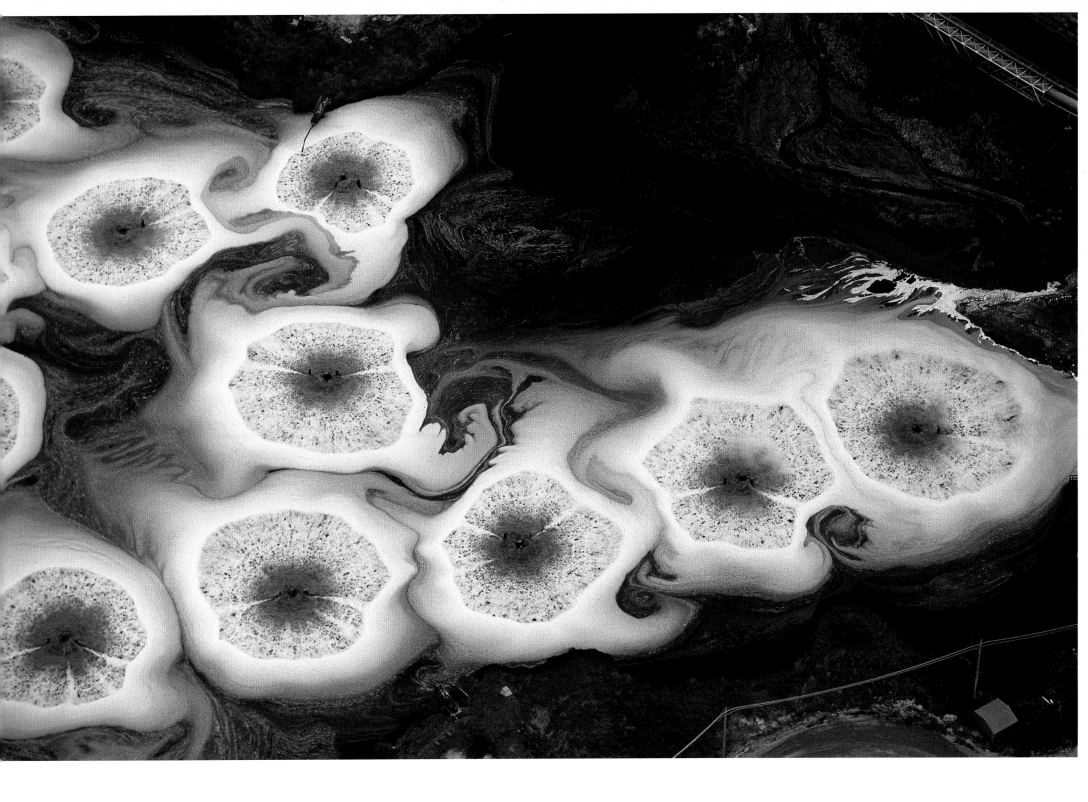

INTRODUCTION

This is a book of photographs of environmental disasters occurring at different points in the consumer/industrial cycle, which illustrate the negative impact our contemporary consumer society has on the planetary systems that sustain our existence. Because of the subject the pictures are inherently political, but my first goal was to create compelling images.

Essays written by some of the top writers, scientists, and environmentalists of our day punctuate the images. They were asked to write personal memoirs with an environmental focus, and the results range from hilarious to heart-wrenching. At the end is an appendix with more information about each image and a graphic representation of the environmental impact seen therein.

The objective of these pictures is not to vilify any given company or industry — there are good and bad actors everywhere. My intent is to engage the viewer, stimulate curiosity, and encourage dialog. Our society's structure has evolved to the point where government responds not to the citizenry, but to the corporations that finance it. These days the vote that matters the most is the purchase decision. Though our government does not defend or respond to us, the manufacturers do. If we all demanded toilet paper made from old newspapers instead of blithely purchasing brands made from old-growth forests, those forests would be saved as would all of the animals who live there, (not to mention the carbon that would remain sequestered). So the goal of these pictures is to promote an activist consumerism. This is a strategy that works; as testament, look at the Toyota Prius and Whole Foods. There is even an organic food section in Walmart.

Tremendous research has gone into understanding what is seen in these images. Information was gathered from numerous sources: newspapers, websites, the EPA (Environmental Protection Agency), EIA (Energy Information Agency), environmental groups, satellite images, and sources within and just outside of the government. However, even these attempts at exposing the problem at hand can sometimes fall short. Due to exemptions granted to powerful industries, some of the most egregious industrial scars are "off the record." The notorious Bevill Amendment to the RCRA (Resource Conservation and Recovery Act) is particularly damaging. For instance, the uranium content, and thus radioactivity, of phosphate fertilizer waste is well known, but due to RCRA exemptions, appears nowhere "on the record," and thus the industry escapes the expense of proper handling. Also, one can only photograph what can be seen; often the most dangerous pollutants are invisible.

I write this after a month of repeated trips over the British Petroleum Deepwater Horizon oil spill in the Gulf of Mexico, and it cannot help but have an emotional effect. Now, if I have to drive somewhere, I feel guilty. I can't bear to drink from a plastic water bottle knowing that oil equaling roughly 1/3 of the volume of that water bottle was used to get it into my hands. One of my responses to the Gulf gusher is to hitchhike. Why burn

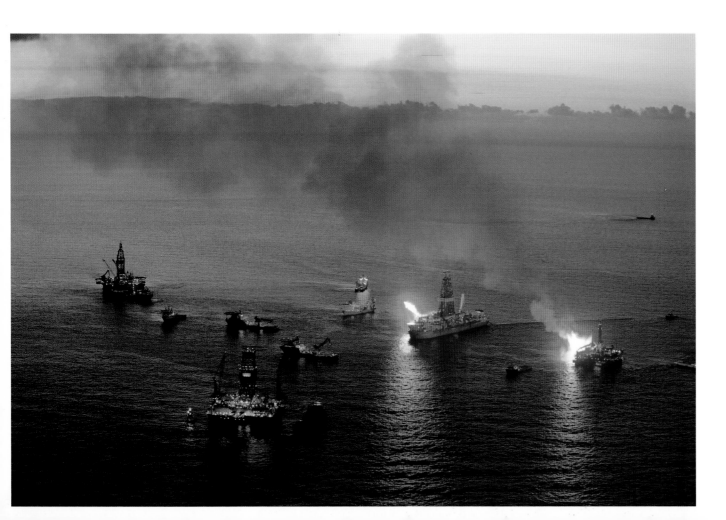

Gulf Of Mexico.
Nighttime view of operations at the
BP Deepwater Horizon spill site show-
ing various vessels. The two flares
are burning off the small percentage
of volatile gases captured from the
erupting well below. The foreground
rig, Development Driller 3, is drill-
ing one of the relief wells that is
hoped to plug the eruption.

gas to get from train station to home (a prosperous suburban area outside NYC)? Usually I have no problem, but last night at 10 p.m., my good neighbors paraded by in their SUVs, shaking their heads at this impetuous ruffian who would dare to degrade their property values by exhibiting this bohemian behavior. Coughing in their exhaust plumes, I wondered how they could not see their complicity in the Gulf.

I'm constantly amazed by the willingness of people to ignore the consequences of their actions, and the real risks to their health and well-being. Most of us live in a world of indulgences, all of which have an environmental cost that will be passed on to our children. "The environment" is the system that supports life, our life. But those who are concerned about it, who speak up about it, are relegated to the status of zealots and simpletons. "Things are too complicated," we are told. "We can't change our economy, business will suffer, jobs will be lost." Meanwhile, the system that provides us the air and water we need to live is going into cardiac arrest. I believe that we could very easily change the direction of our society and economy toward sustainability with nothing but benefits for our children, ourselves, and our economy. The only losers would be those currently making fortunes from destruction and exploitation. We have the power. Spend your dollars with your children in mind.

J Henry Fair
New York, 2010

CRISIS IN THE GULF

Deepwater is a crisis of first order, and a crisis, as they say, is an opportunity not to be wasted. But missing the point seems to be the order of the day as we fret about blame and oily pelicans. There is no doubt that our regulation and permitting processes must be revised, and negligent parties held responsible. But the fact is that those oily birds and dolphins are doomed, and as long as it is allowed, oil will be extracted from the farthest reaches of the globe at the least cost possible. The real discussion about how to keep this from happening again must be centered on our energy future. Every government in recent times has parroted the truisms that we must wean ourselves from oil and graduate to sustainable energy sources — and then proceeded with business as usual. Our representatives are "elected" with the help of vast contributions from the oil companies that have a vested interest in the status quo (the biggest beneficiary of BP's largesse between 2004 and 2009 was President Obama, to the tune of $77,000). To expect that politicians will orchestrate a change in the current system is unrealistic.

If we want change, we must force it. I herewith reject any protestation of impotence. What can you do? Ride a bicycle, buy a wood stove, insulate your house, and turn off your boiler (only turn it on to take showers). The solutions are there; we must discard apathy and complacency and demand them. You can do something about this (if you really want to.)

Barataria Bay, Louisiana.
Shoreline concaves on this barrier island
rookery collect oil of different weights
drifting from the BP Deepwater spill.

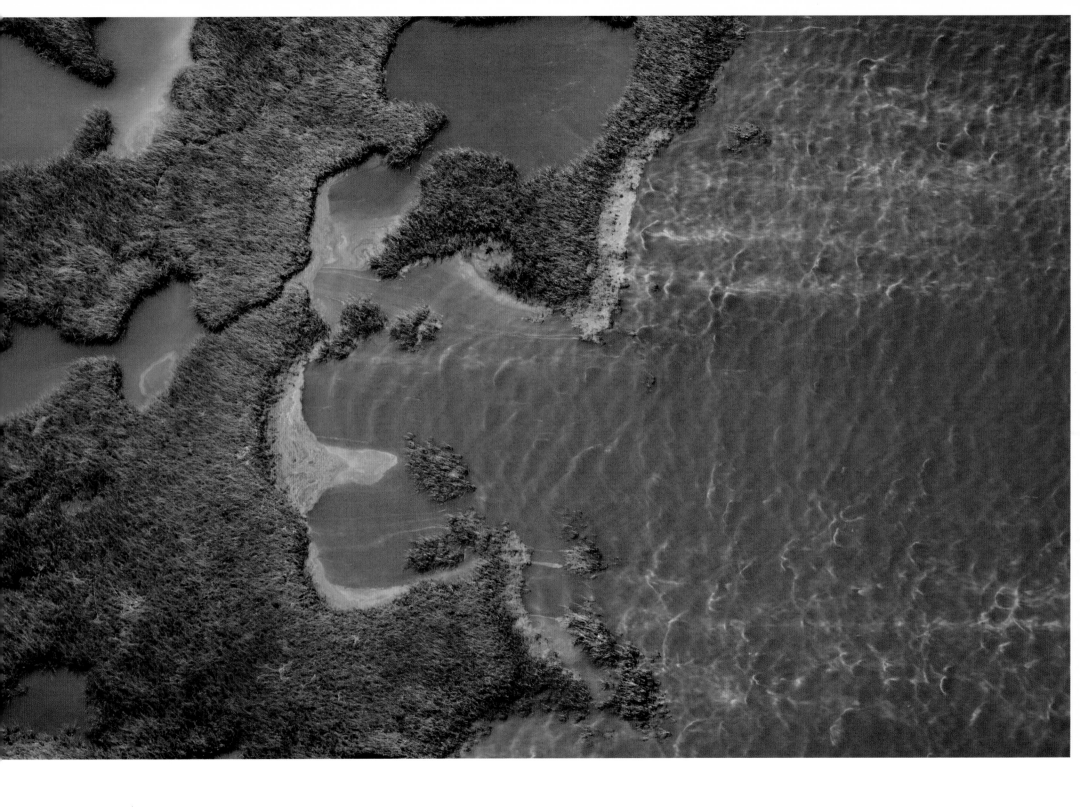

Gulf of Mexico.
Many different compounds are emerging
from the subaqueous Macondo well,
including different types of oil.
Here, two are interacting.

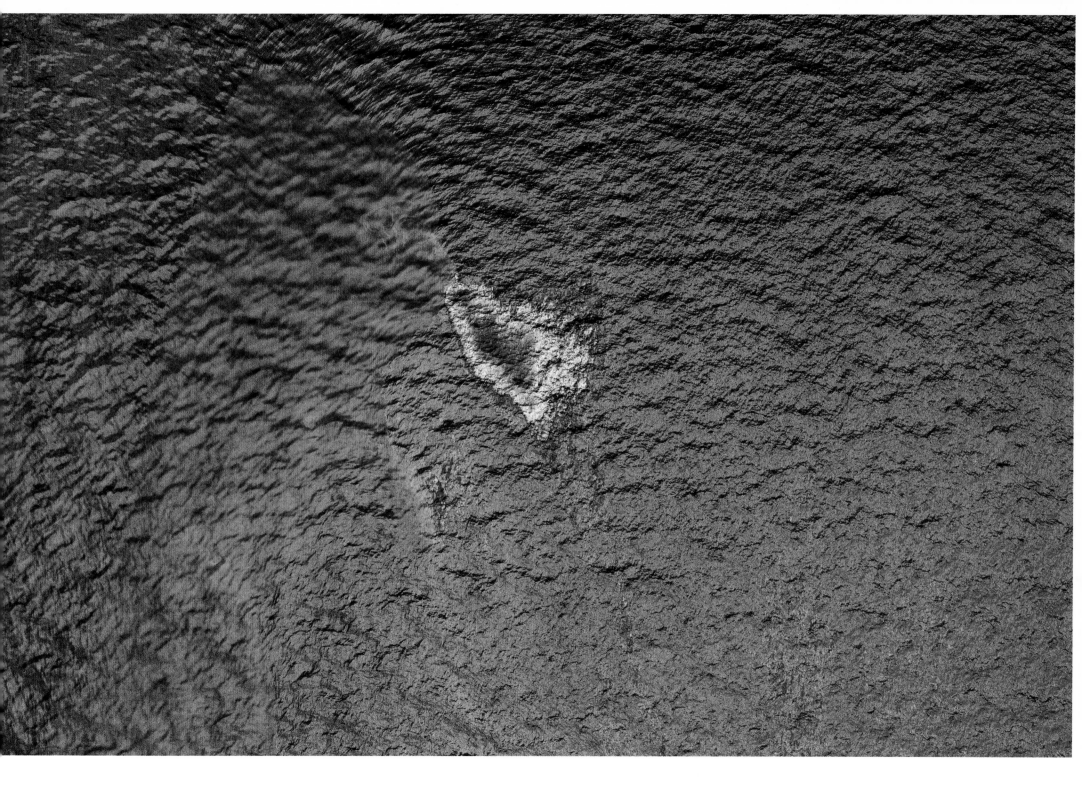

RESOLUTION

I'm flying across the Atlantic Ocean, routed north because of Iceland's spewing volcano. From 39,000 feet aloft the ocean changes from soft green to graphite to black, then soon to silver as the plane crosses time zones into early dawn. Strapped into my 36A slot, I feel a surge of exhilaration. The mighty Atlantic and the volcano blowing its top — how powerful the Earth!

We're hurtling through air we couldn't survive in for three minutes, heading for one of the most timeless cities on Earth: Roma. Soon the plane pushes through the clouds; suddenly the fabled coastline angles across the small window and then immortal, red-roofed farmhouses and green fields appear. We're landing. As I exit from the nether regions of the plane, I notice how many empty plastic bottles are stuffed in seat pockets, strewn on the floor. Business class, with downy quilts flung hither and yon, looks like a scene of debauchery, only it was plain old water they were drinking, not some mead of the gods. I remember I have a plastic water bottle in my bag. The wine I drank aboard was in a plastic cup. The "silverware" was plastic, as were the containers of "food," and the tray they were served on. The old movie *The Graduate* was prophetic; plastic was the future then — and now we're in that future.

As I write this two days later, black oil is roiling into the heaven-given aquamarine clarity of the Gulf of Mexico. There's a scheme to put a box over the leak. My eight-year-old grandson said, "If it even works, what's that going to do to the ocean floor?" What, indeed, mouth of babe? The greed to drill outpaced technology to contain in case something went wrong, terribly and tragically wrong.

With 3,500 rigs in that sacred water, stuff like this is going to happen, not just this once. And then there's the Pacific trash vortex, a miasma of 3.5 million TONS of mostly plastic. It's twice the size of Texas and bobs in the waves between Hawaii and California. The same plastic water bottles on the floor of the 777. They're everywhere — from endless landfills to the canals of Venice, a place of sublime beauty.

These two cataclysmic outrages, I realize, are only two of many. We've botched it big time. Where's the outcry, the demand to curb our spendthrift ways? My rage shoots forth like that gush of oil. Foolish rage, impotent rage? Am I like Sister Orsola Benincasa? Her heated body used to hiss like a red-hot iron and steam issued from her mouth.

What are we thinking?

Where's the war against terrorizing the oceans?

On nights of insomnia, I visualize a sloop skimming over tropical waters, the clear view to the rippled bottom, the clean salt sting as a wave smacks the bow.

Our waters! How we flock to them for renewal all summer; how we have from childhood; Masefield's strong urge to "go down to the seas again." Now we all must know, as poet William Stafford put it, "the terror of having such a great friend, undeserved." Isn't the percentage of salt in my body the same as in the waters of the oceans?

This morning at the tiny grocery store in my adopted Tuscan town I saw a truckload of bottled water. Surely the mania for water in a bottle is a holdover from when wells were shallow and people searched for springs where they filled their glass demijohns with pure *acqua*. Until recently here, bottled water came only in glass. Now it's mostly plastic and it surprises me that Italians, who are such natural gourmets, will drink water that slightly reeks. Plastic is a terrible medium for storage, imparting as it does quickly, that dead taste. Not so long ago we all got by without carrying around a plastic bottle as though we are top athletes who must constantly hydrate from our exertions. (And people look plug-ugly drinking out of bottles, especially those with the weird tops you suck.)

I drive a hybrid. I take my own bags to the store. I don't use chemicals in my garden. Yes, recycle, vote for candidates who give a damn about the Earth, search for green products. Henry Fair even has me giving up paper towels. Whoop-de-do — this, I know, doesn't reduce the Sargasso Sea of garbage in the Pacific or stop a drop of oil from surging into the Gulf.

But anyway, now, today, this minute — a vow. Just for myself. Not for water, certainly, but not for soda, laundry soap, bleach, mustard, peanut oil, or juice. *Niente*. No more plastic bottles.

Frances Mayes
Cortona, Italy, 2010

Gulf of Mexico.
A small portion of the volatile gases emanating from the Macondo well a mile below is captured and piped up to the *Discoverer Enterprise* drill ship which flares it for disposal. The heat is so intense that water must constantly be sprayed on the nozzle arm to protect it.

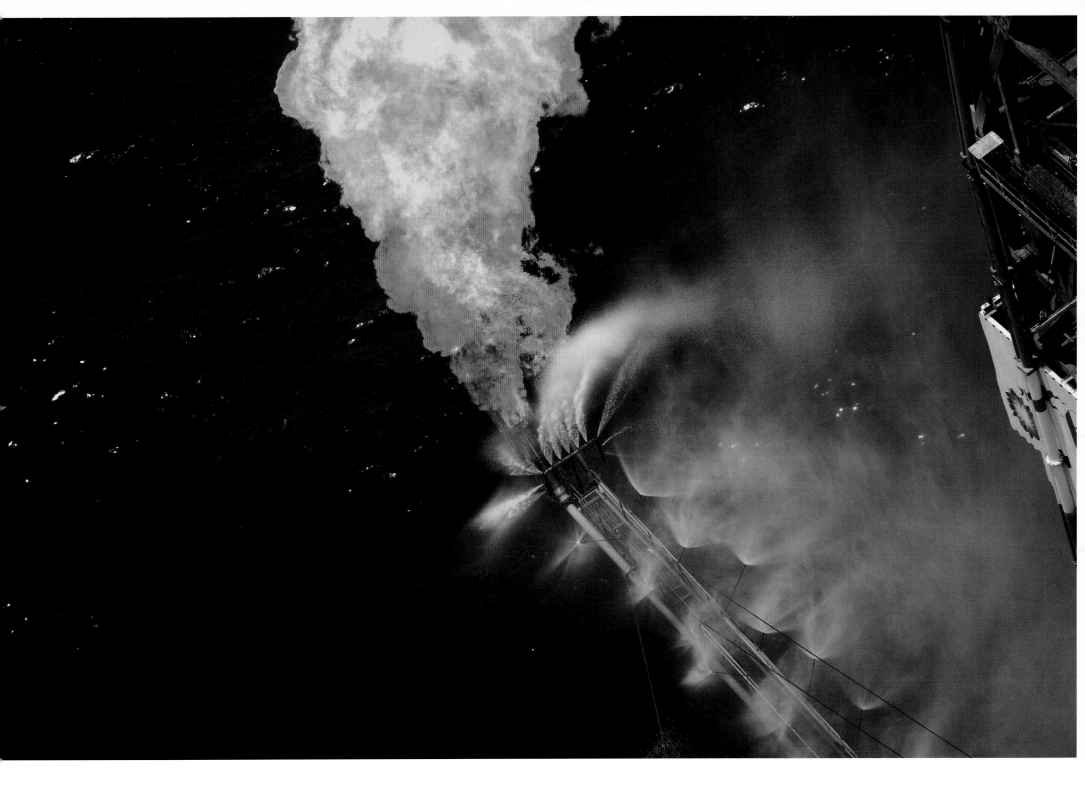

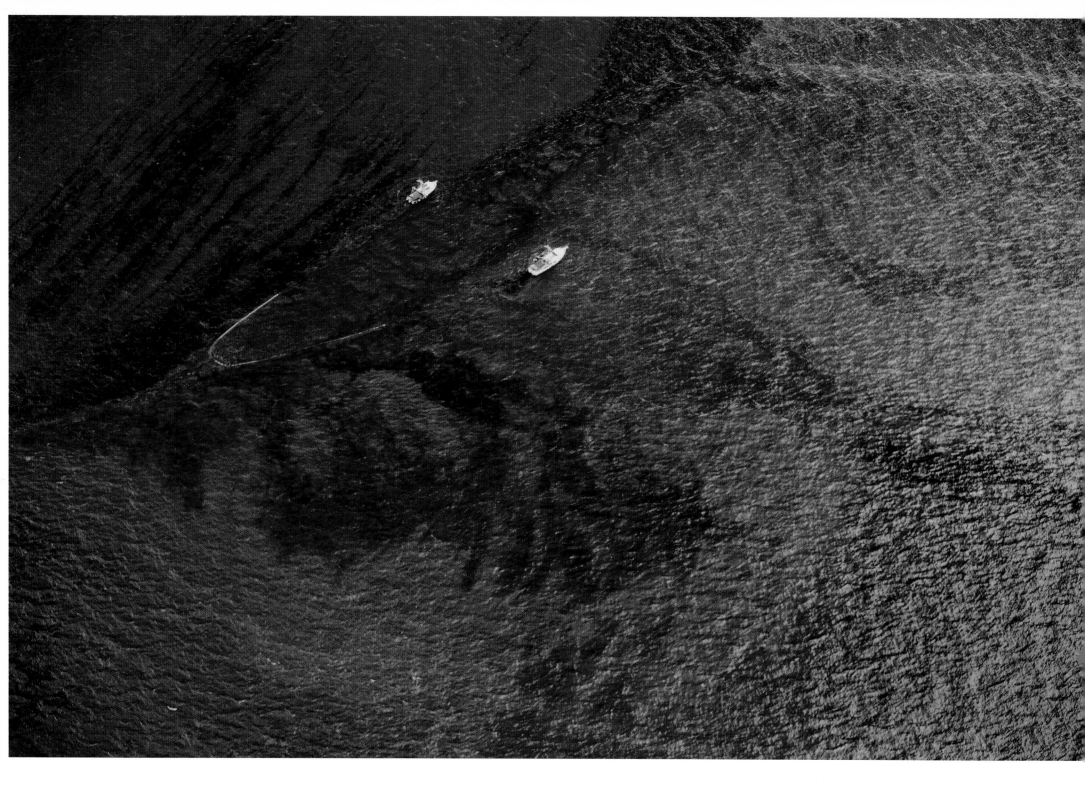

Gulf of Mexico.
< Ships skimming oil from the BP spill.
On the right is a large mat of oil and
on the left clear water with strands of
thick oil. Skimming often catches sea
animals such as turtles, who perish when
the collected oil is burned.

> Oil floating on the surface of the
water is extremely reactive to dis-
turbance, whether by wind, current or
vessel, and often forms interesting
shapes.

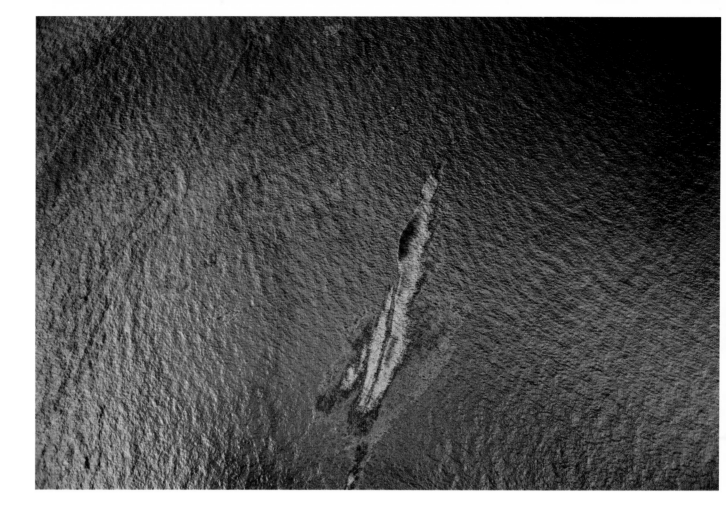

FROM THE BEGINNING

One could argue that our definition of beauty has evolved with the industrialization of our society. Whereas once, only pastoral, organic settings and images were considered beautiful, suddenly images of smokestacks and train tracks became anointed as works of art. Conversely, there seems to be a concurrence between the industrial revolution and an increase in the popularity of landscape painting, as if in an attempt to capture a "paradise lost." Photographers have long glorified the beauty of the machine, ever since the invention of the camera itself. Perhaps it is no coincidence, considering photography is the quintessential art form of the industrial revolution, but more likely the allure of machinery was born of the fact that machines represent the pinnacle of functional beauty. A parallel theme in photography is the alienation of man in the face of industry. These images comment on those photographic schools, and lead toward the later abstracts.

Near Dakar, Senegal.
Factory, farmers, and dust.

Southern Senegal.
Old machine parts arbitrarily strewn around a field.

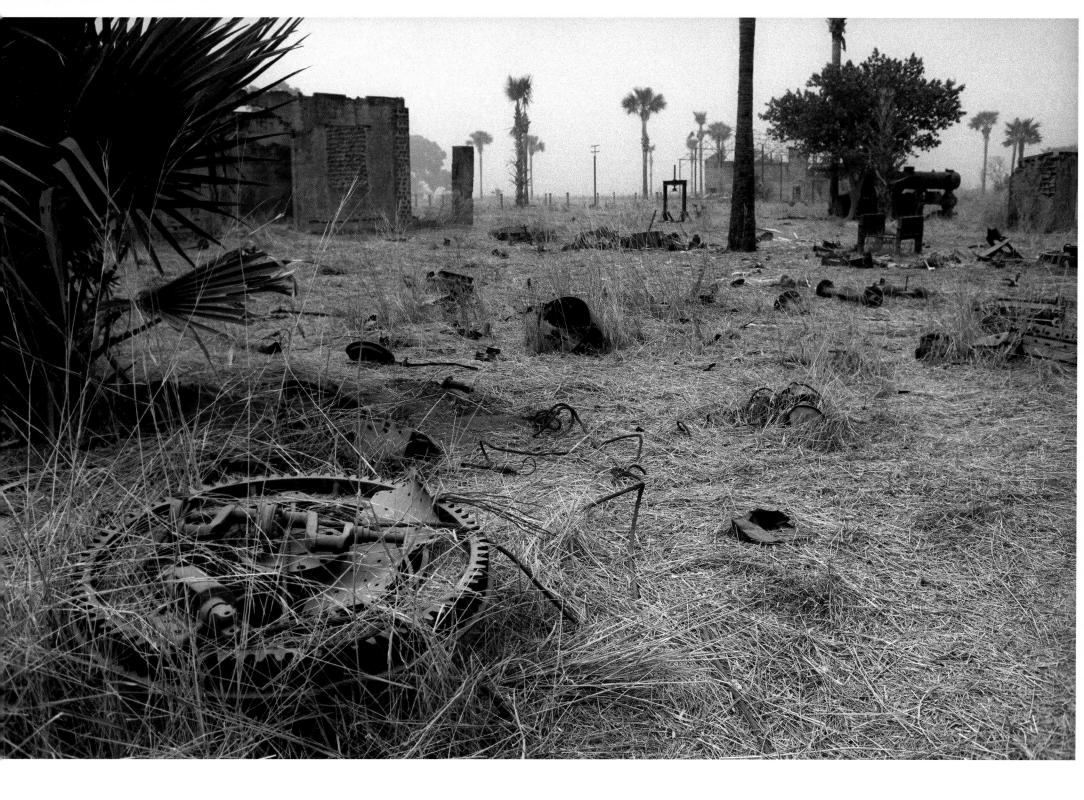

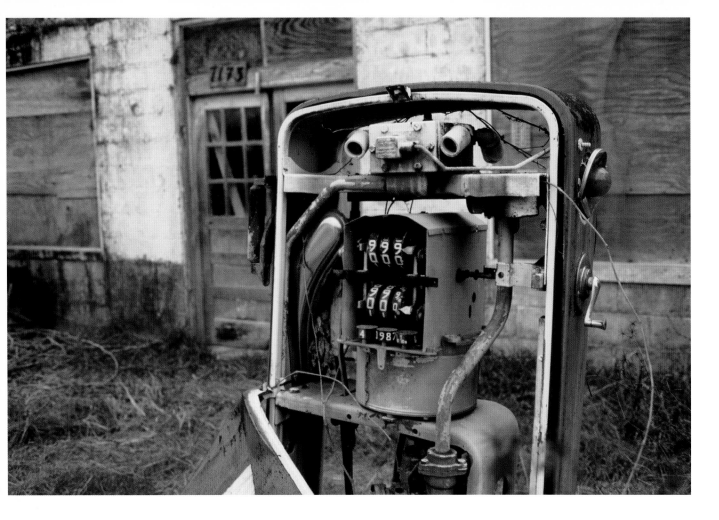

< Awendaw, South Carolina.
Decrepit gas pump.

> New Rochelle, New York.
Clock face on control panel at garbage
incinerator.

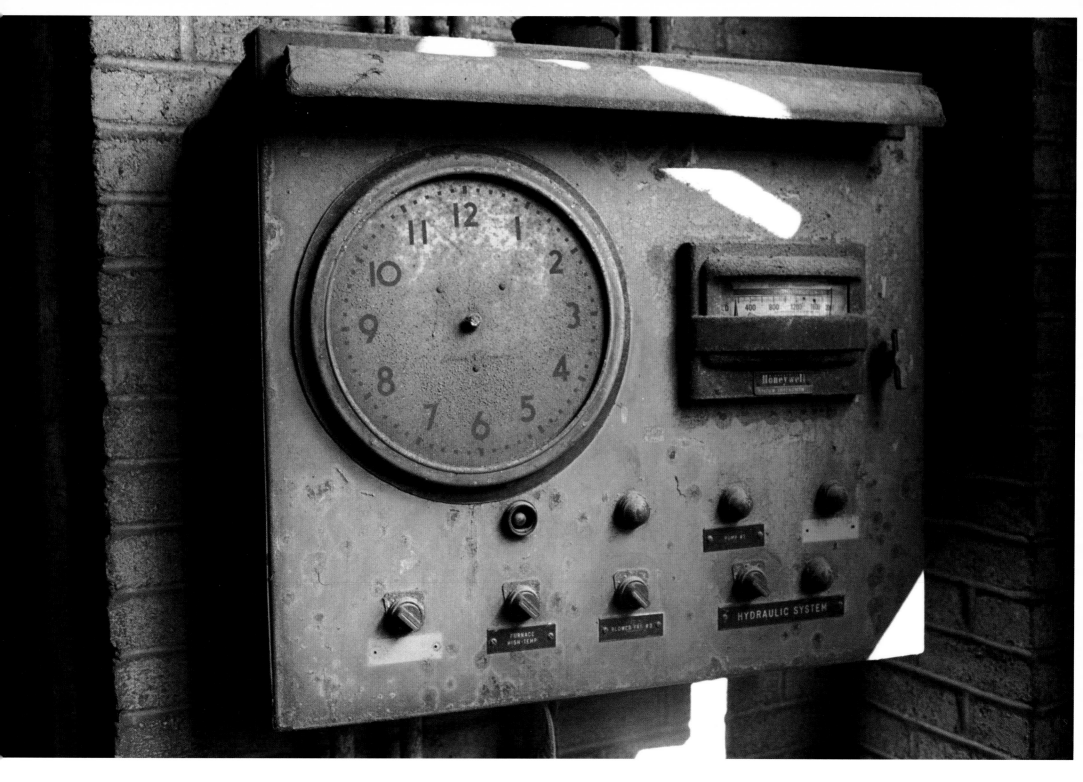

Belle Chasse, Louisiana.
This refinery on the Mississippi Delta
processes raw crude into gasoline,
diesel, and jet fuel. About 40 percent
of our refining capacity is on the
hurricane-prone Gulf Coast. After
Hurricane Katrina, this refinery was
closed for 235 days.

Middle USA.
The smokestacks indicate that this
is probably a coal-fired power plant.
According to *Harper's Magazine*: "The
estimated portion of all freshwater
drawn from U.S. sources each year that
is used to cool power plants: 1/2."

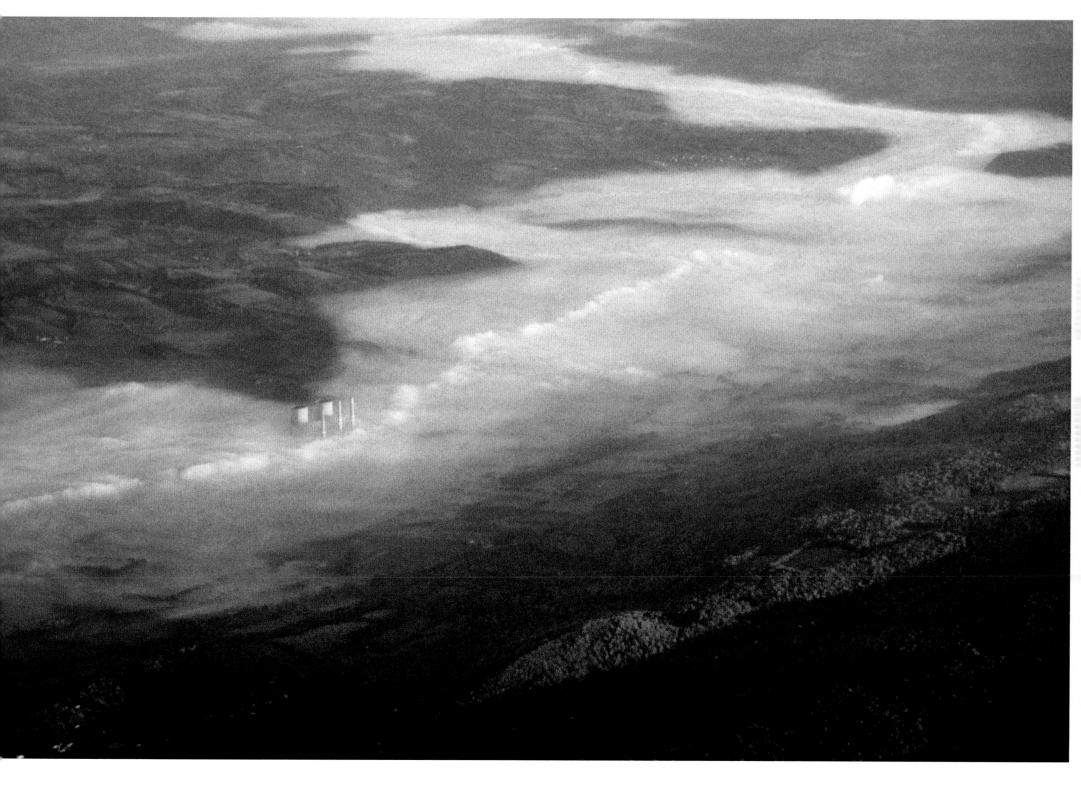

LIFE ON THE MISSISSIPPI

The Mississippi runs through the middle of our culture as it does our nation, dividing East from West, frontier from settlement, and new from old. This waterway, seemingly immutable, a microcosm of our nation's ecological history, has slipped from mighty to ravaged in less than a century. In 1866, Mark Twain, a man responsible more than any other for inserting the dream of the Mississippi into the imaginations of all Americans, remarked, "The Mississippi River will always have its own way; no engineering skill can persuade it to do otherwise." Sadly, this statement no longer applies, as the mighty river has been channeled, chopped, and choked by the increasing industrialization of the past century and a half.

The road from New Orleans down the Mississippi Delta seems endless; a monotony broken only by the occasional refinery, oil rig, or cow field. Venice is a small town at the end existing only to serve the needs of the oil company operations in the Gulf. After making the pilgrimage to Venice numerous times, passing towns like Port Sulphur and Buras, sneaking into refineries and coal loading facilities, running from the guards with my heart pounding, I suddenly had the inspiration to hire a plane and see it from the air, choosing as the first site the corridor of the Mississippi known as "Cancer Alley," between New Orleans and Baton Rouge.

I had been trying for years to make photographs that effectively communicated the ramifications of our pell-mell race to dysfunction. Pictures of deforested hillsides and refinery pipes don't move people, because we have seen it all before and are a bit jaded, but also because they don't stimulate an aesthetic response. Aerial photography was a revelation. It offered both access to otherwise off-limits sites of pollution, as well as an amazingly appealing visual perspective from which to view and photograph these hidden disasters.

Zachary, Louisiana.
Waste from a paper mill is agitated by
aerators, producing steam and foam,
which are pushed by the wind.

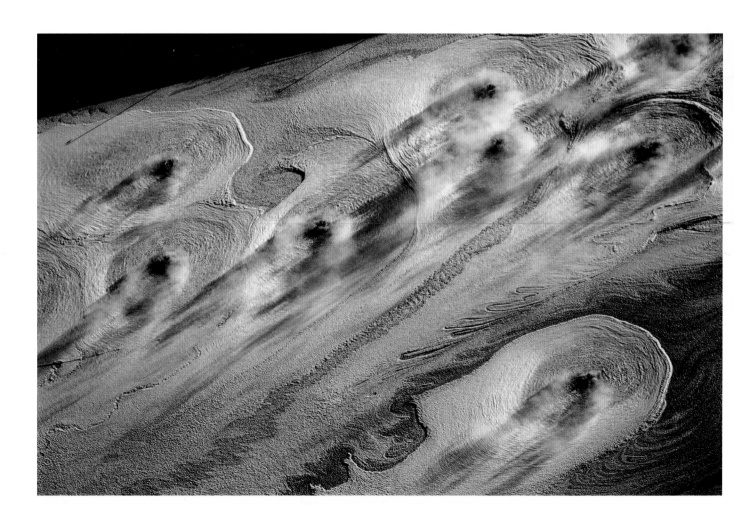

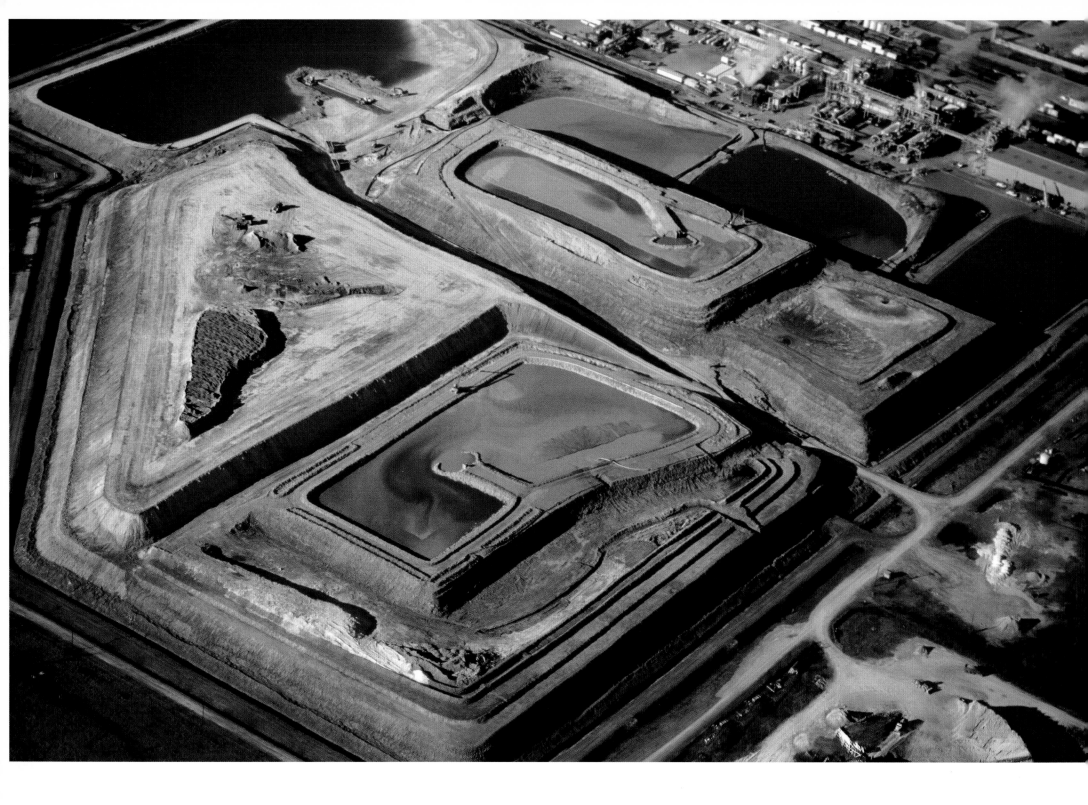

Geismar, Louisiana.
Waste from the manufacturing process is
pumped up to the impoundment, the walls
of which are created by an excavator
that scoops the solids from the liquid
and applies them to the embankment. This
image was from my first flight over this
site, and several years were to pass
before the process was identified.

Gramercy, Louisiana.
Bauxite waste. Aluminum production has a tremendous climate change impact with both the gases released and the tremendous amount of electricity needed for the process.

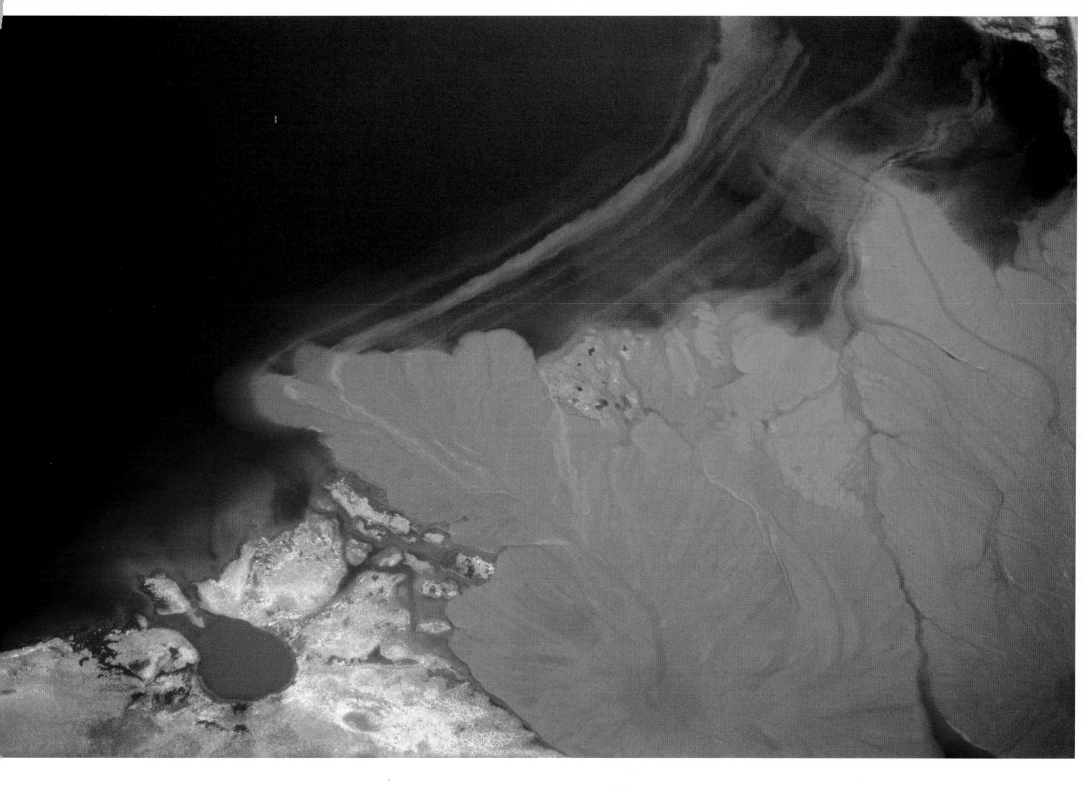

New Roads, Louisiana.
This power plant, fired by coal, supplies power to Baton Rouge and the industries along the Mississippi River. It is one of the 50 largest emitters of mercury in the USA, and releases 14,300,000 tons of carbon dioxide per year.

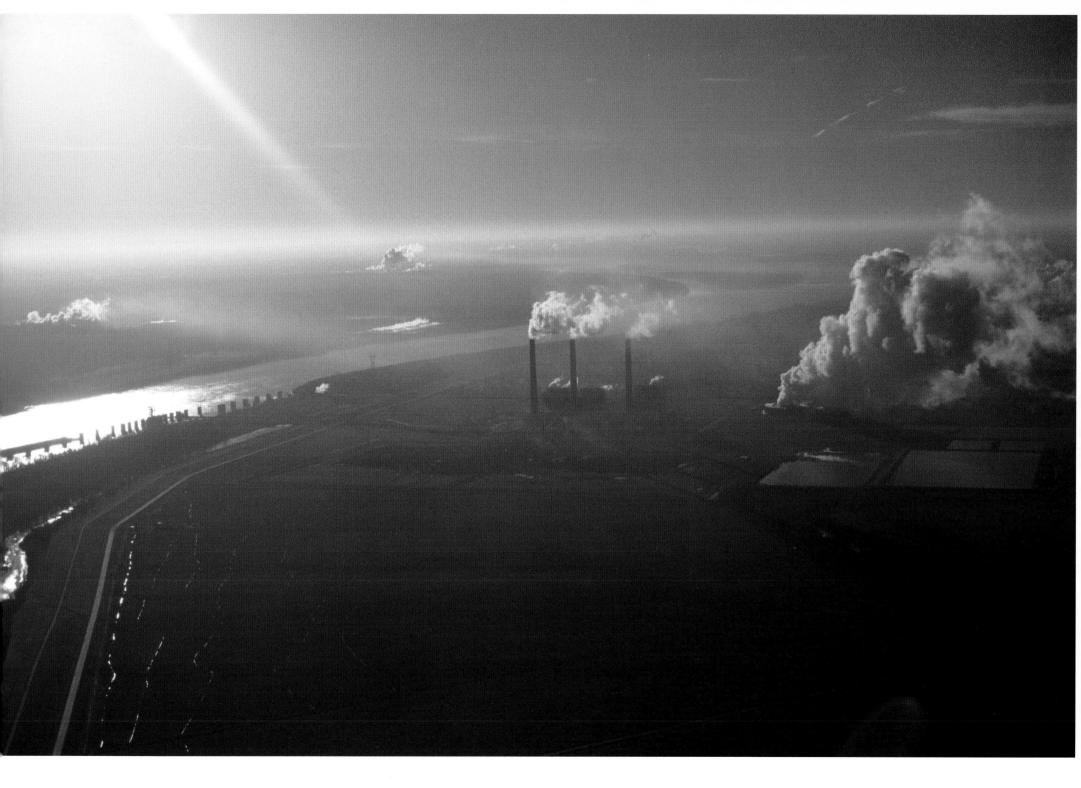

A NEW AMERICAN DREAM

The country is in the throes of an argument about who it is. It has not really admitted this — instead the media talks about red state vs. blue state, Tea Party vs. Grand Old Party, but really we are in the midst of an identity crisis.

It is a crisis of beliefs and values and ways of doing business that have been embedded in the American Dream since the Mayflower. I have been part of that dream. My ancestors came over on the Mayflower — one was a manservant named Howland who fell overboard and, rather improbably, was rescued. He and the rest of the "first comers" believed that hard work would set you free. And indeed they prospered — through subjugating nature, Indians, and people who did not agree with their Puritan interpretation of Christianity.

On my mother's side of the family, I descend from a Spanish/Mexican mixed blood named Ortega who went conquering up the California coast with Gaspar de Portolà and was put in charge of the Royal Presidio of Santa Barbara, where he went merrily about chaining nature, Indians, and people who did not agree with Catholicism.

And then we have the Moore brother ancestors who during the 19th-century gold rush in California drove cattle over the mountains to sell to the starving miners, taking most of their gold in exchange.

Or the Irish immigrant ancestor who went from poverty to being a multi-millionaire by coming up with the idea of the corner tobacco store, which led to United Cigar Brands, which led to Phillip Morris buying him out, which led to lots of money until the stock market crash of 1929. Oh, and it led to cancer too, though not for him.

We have many stories like this that are a part of our family lexicon.

The American Dream beats so strong in my breast that I am proud of this motley crew, who made their way exploiting others and the environment. Proud of them because they worked

hard, succeeded against difficult odds, demonstrated vision and leadership, grabbed strategic opportunities, made money, and made history.

I am proud of Americans in general, who (surveys say), work harder than any other people in the world, who are continually inventive and forward-thinking, who are generous with worthy causes, and who are not afraid to lead, to take risks, to think big.

And yet look what this has led to: Native Americans murdered and marginalized; natural resources squandered and destroyed; an elite 5 percent controlling most of the business and most of the money in the country; people working longer work weeks than peasants did in medieval times and getting stressed and sick; Americans buying clothes, cars, houses, and electronics to make them happy, but ranking themselves at #114 in the global happiness index.

We need a new American Dream. It's not the values that are wrong, it's the objectives that are wrong. Lots of money. Lots of stuff. The right to buy whatever we want even if it is poisoning people and the land.

More, more, more.

I say — enough.

Let's unleash our ingenuity, our energy, our passion, and create an American Dream that helps us to *be* more rather than to have more. An American Dream that satisfies and sustains us like a delicious home-cooked meal and not a bar of candy that gives us a nice quick high and a nasty hangover.

We need a new American Dream.

Tensie Whelan
Danby, VT, 2010

New Roads, Louisiana.
Bulldozer tracks and yellow liquid in ash waste from a coal-fired power plant. This facility produces 860,640 tons of coal combustion waste (CCW) annually, making it one of the dirtiest in the USA.

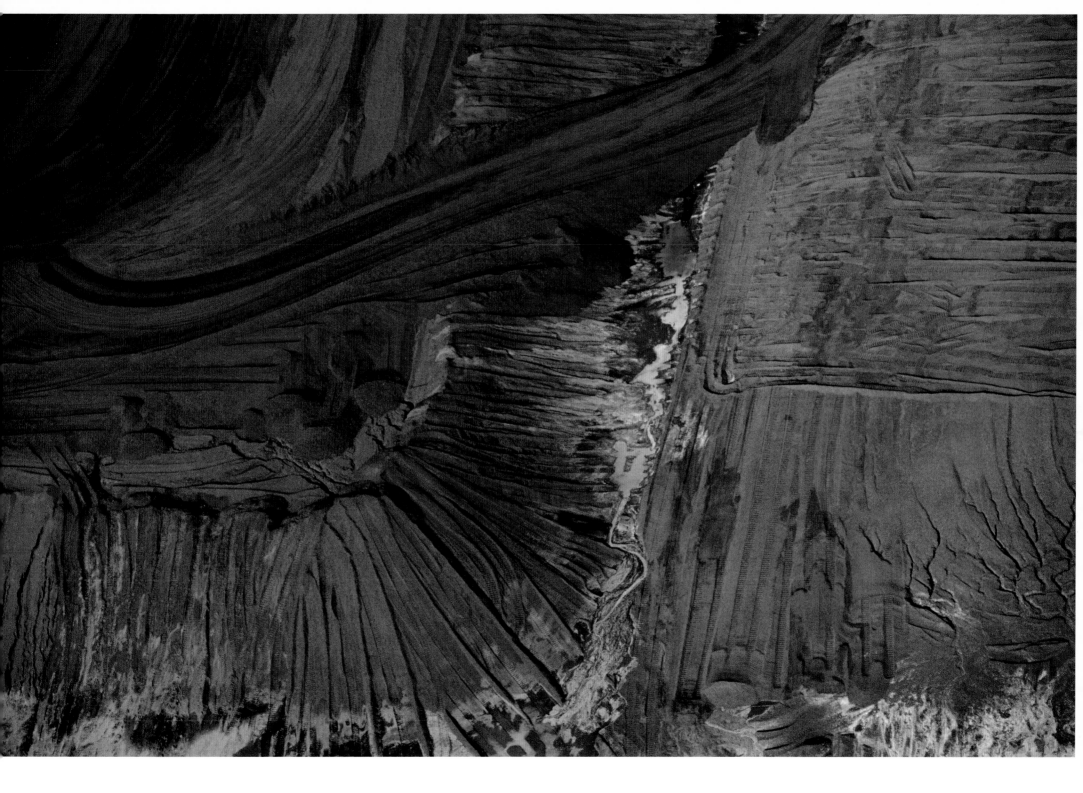

Zachary, Louisiana.
This mill on the Mississippi River
makes paper towels and printer paper.
According to the Organisation for
Economic Co-operation and Development,
the paper industry is the largest single
industrial user of water, and the third
largest producer of greenhouse gases.

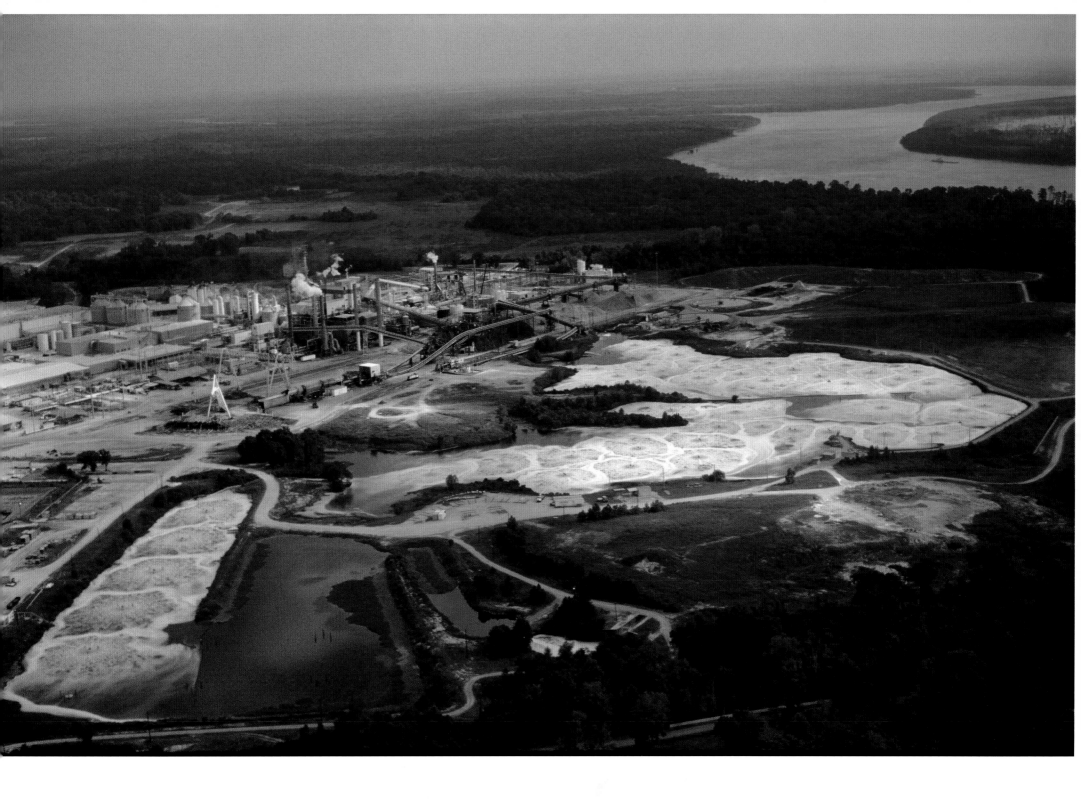

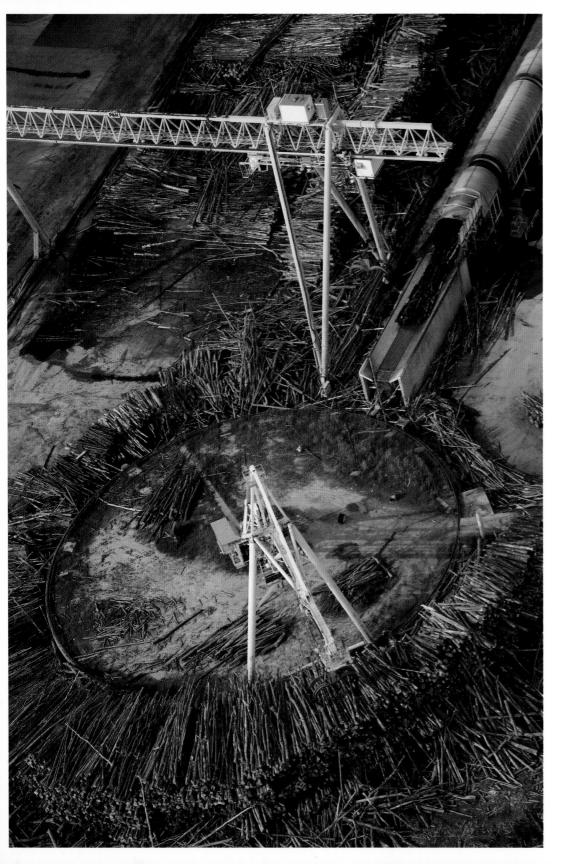

Zachary, Louisiana.
Trees to supply pulp for this mill are cut from forests along the Mississippi and trucked to this facility. Here the loader feeds them into a hopper that will take them for pulping.

Baton Rouge, Louisiana.
The ruins of this aluminum refinery are the visible remains of this vanished industrial giant. The hidden remnants include mercury and groundwater contamination.

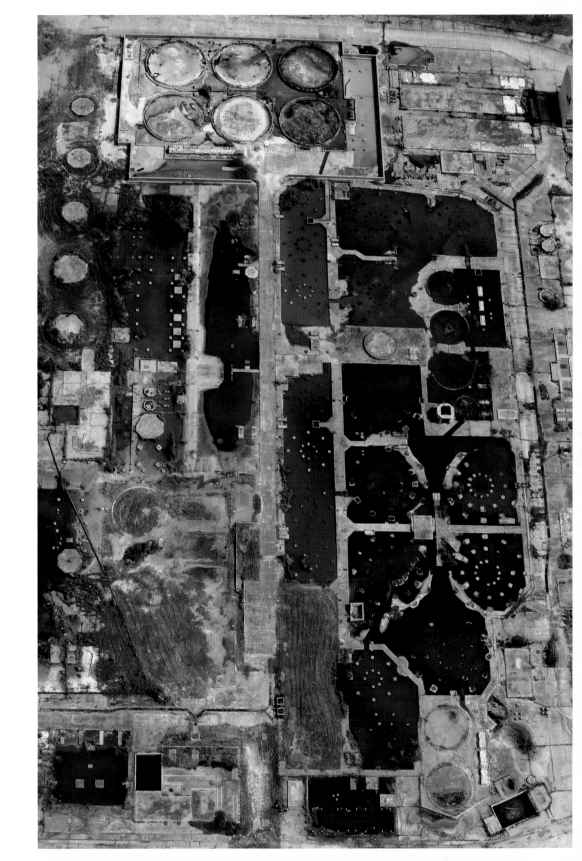

Bad, or at least deeply flawed, artists can make great art. Art doesn't necessarily make you wise or socially or morally correct, however much we'd like to think so. Art itself doesn't improve society or mankind. Pictures of horrible or scary things might use art, use beauty, to lure a viewer into a contemplation of non-artistic issues. But art shouldn't itself be reduced to a teaser for something supposedly higher or better.

The closest parallel in human experience to art is probably religion. Those who love art, who are thrilled by it or caught up in it to the point of rapture, experience something similar to what a believer experiences from an encounter with the Divine. Art becomes a revelation not of something higher than itself, but rather of itself.

That is why moralists and rationalists have long been suspicious of art, starting at least as far back as Plato. Art is something so powerful that they can't control it, can't channel it to purposes they consider more proper. Art can't make one more environmentally conscious. Conceivably, one could look at photographs of environmental ruination or hubris and find them so beautiful that one would be inspired to charge out into nature and despoil it some more, if only to create still more beauty that could then be photographed.

Which is hardly to say that beautiful pictures of horrible things should be suppressed. Our very awareness of art's twisted relation to evil makes its contemplation more compelling. I have a lifelong fascination with German culture in general and Richard Wagner in particular. Up until 1933 Germany boasted the most sophisticated, complexly

rich culture in Western civilization. Yet it produced Adolf Hitler and the Holocaust, a horror in some debatable sense foreshadowed by Wagner's anti-Semitism and the grandeur of his music dramas.

When I sit for long hours at Bayreuth, am I morally compelled to think of Auschwitz? If I enjoy a rap song, must I brood upon homophobic gangsta thugs calling women bitches and hoes? Some people angrily think that I should, in both cases. I do not. For me, the artistic experience can speak for itself. Afterwards, any of us is encouraged to think back upon the experience, to knit art back into our social and moral, and political ethos.

An opera or a photograph can be both artistic and overtly political. But unless the artist explicitly deems the art to be secondary (as Brecht came very close to doing), it is wrong to assume that it is secondary, that the "real" world automatically trumps the aesthetic.

Retroactive reflection on the role of art in society only enriches the overall artistic experience. It enriches life itself, of which art may be only a part, but for some of us a part that need take a deferential position to no other. The deeper the connections between art and life, those perceived in the contemplative postlude to the artistic experience — even if those connections seem initially contradictory, as in a beautiful rendering of something ethically and politically abhorrent — the deeper the art.

John Rockwell
New York City, 2010

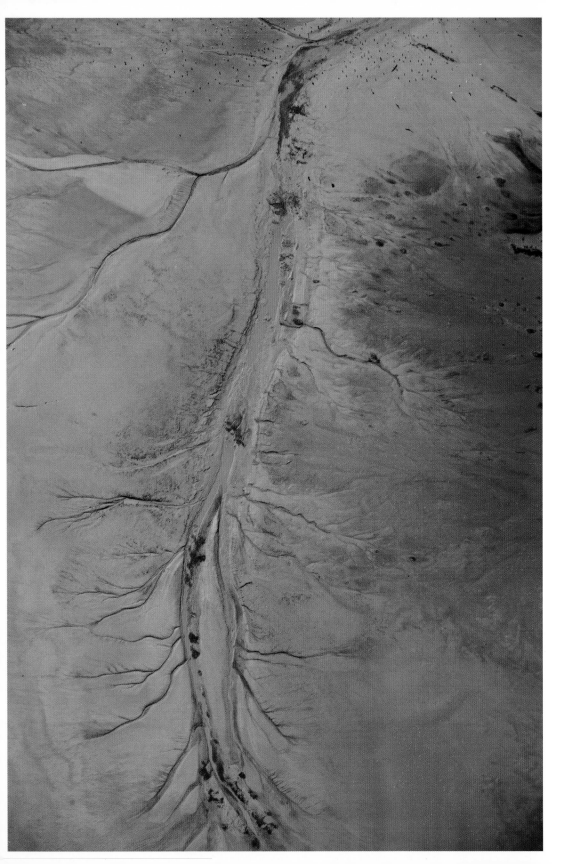

Baton Rouge, Louisiana.
< Rainwater collects in this waste area from the abandoned aluminum plant pictured on page 49. Long after the industry is gone, with its jobs and economic support, the environmental legacy will be funded by the taxpayers.

> Same site, four years earlier.

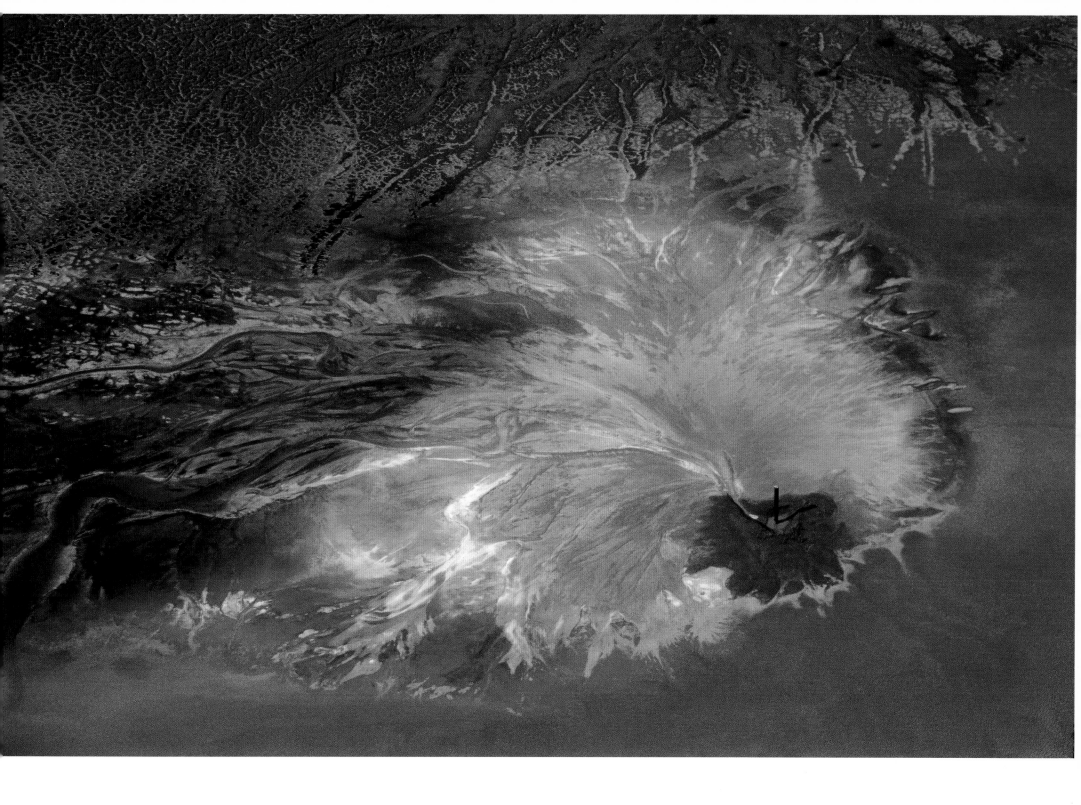

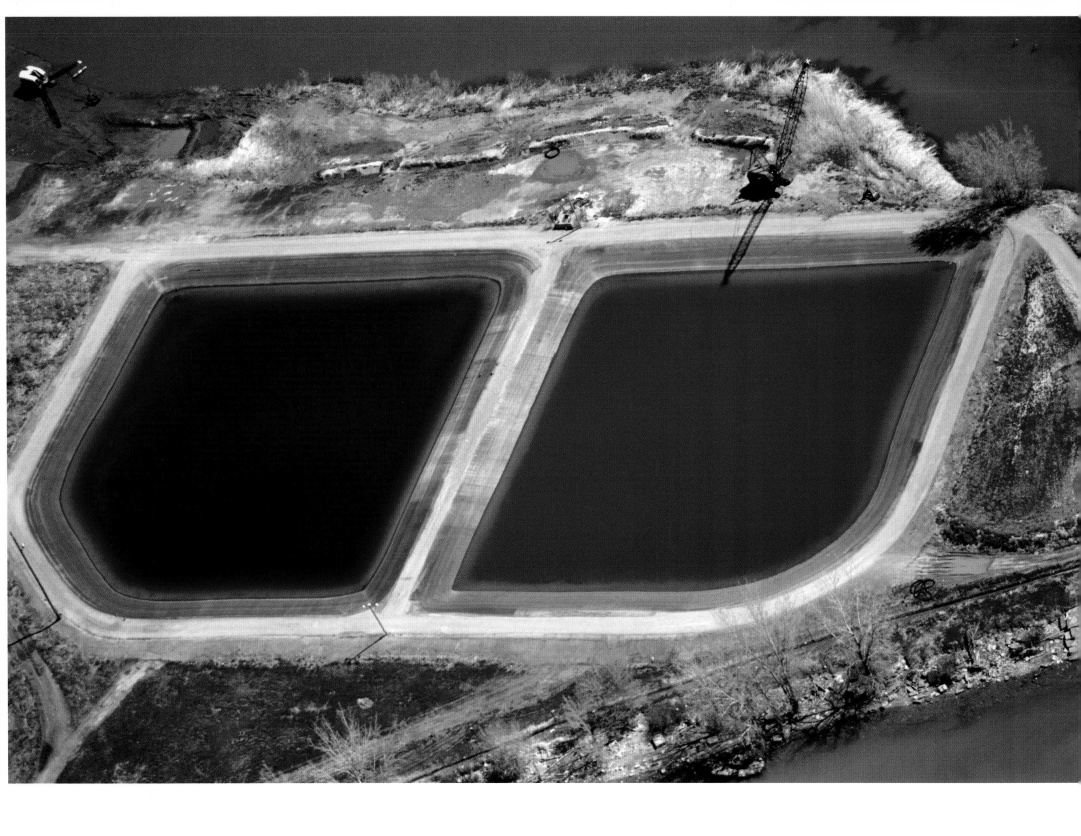

Tonawanda, New York.
Both the combustion ash and the smoke-
stack residue from coal-burning power
plants are extremely toxic. Coal plants
are the largest source of radiation
released into the environment, and
frequently contaminate groundwater
with arsenic leeched from ash waste.

Zug Island, Michigan.
Waste pit near Detroit auto factories.

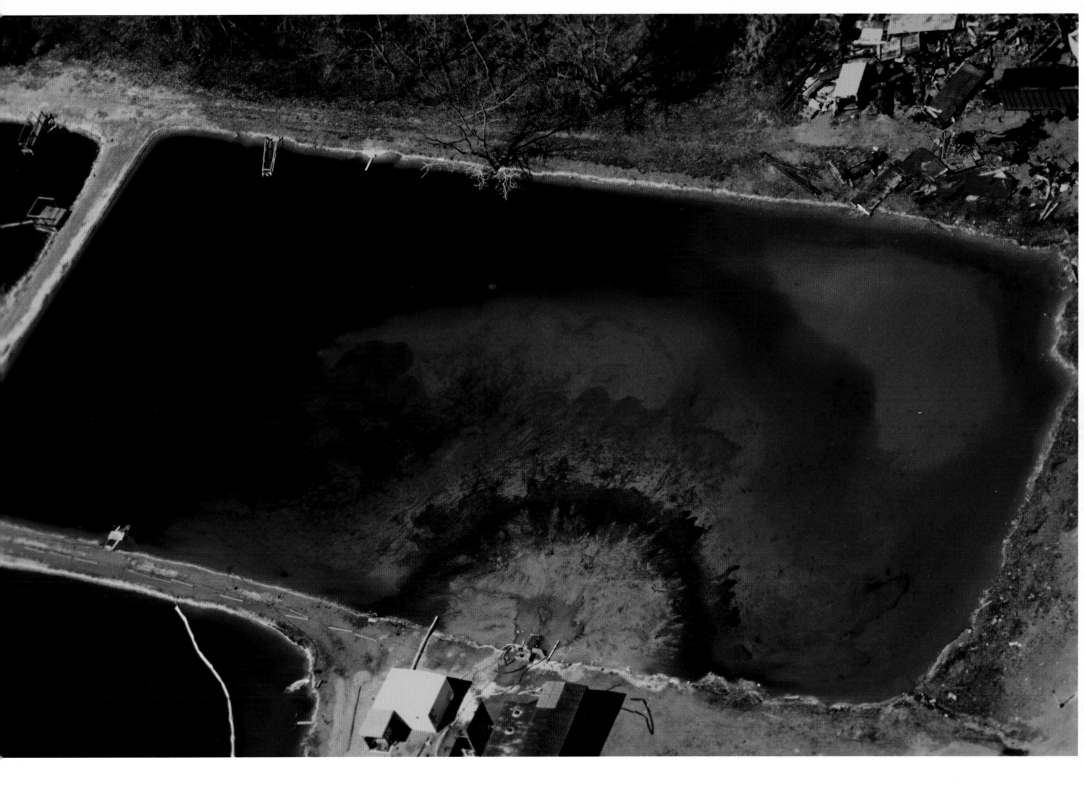

JUST A FACIAL TISSUE

What could be more innocuous than a facial tissue? Who thinks twice about pulling it out of the box to wipe a bit of leakage from the nose or mouth? In actual fact, innocuous should be the last adjective applied to this most modern of conveniences. Depending on which brand the consumer buys, that unconsidered swipe could be the cause of global warming, water pollution, air pollution, deforestation, and habitat loss. Large swaths of The Kenogami Forest in northern Ontario are being clear-cut for pulp to make toilet paper and facial tissue.

Boreal forests, also know as the taiga, form a ring around the top of the planet combining to form the Earth's largest terrestrial ecosystem. Comprised mostly of pine, spruce, balsam fir, cedar, larch, and poplar, the forests provide a habitat for wildlife, generate oxygen, purify water, and sequester carbon. The Canadian boreal is a uniquely beautiful ecosystem, and a joy to see from above.

It seems a horrible joke that we are cutting down an old growth forest to blow our noses.

Carry a handkerchief.

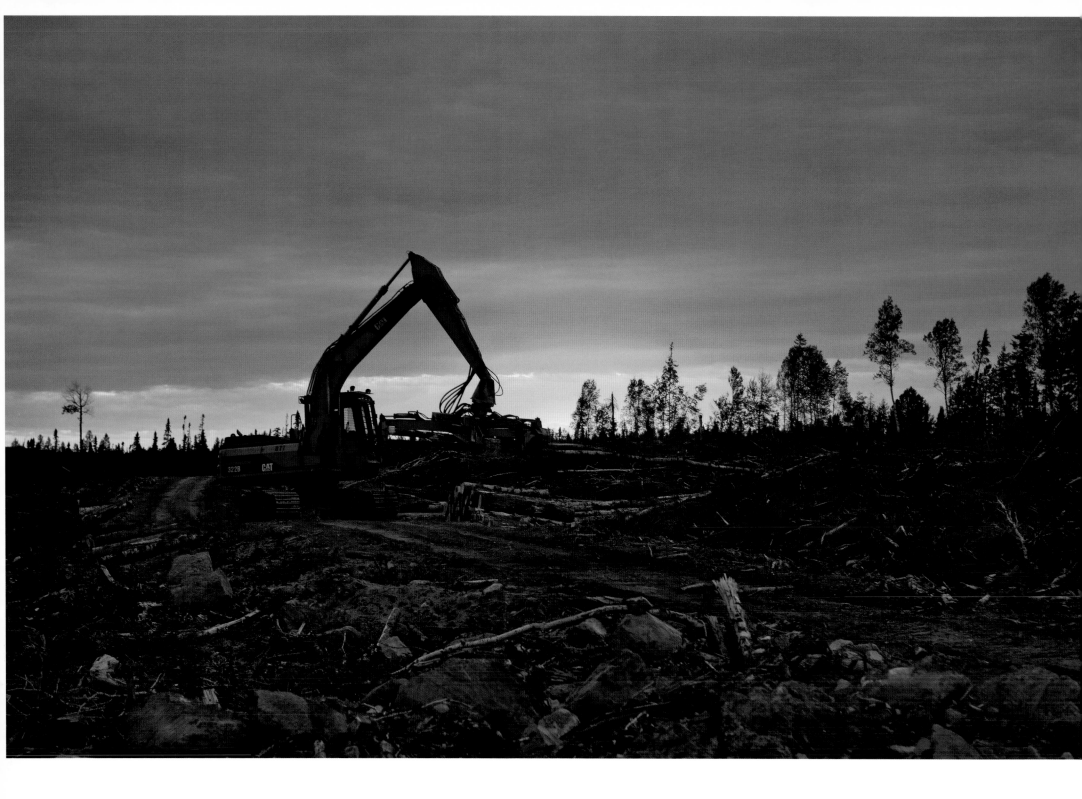

Kenogami Forest, Ontario, Canada.
Machine cuts logs to length after clear-cutting. Logging is subsidized by the Canadian government for "job creation," though in fact the process is so machine intensive that very few jobs are created.

Kenogami Forest, Ontario, Canada. Trees stacked in preparation for pulping. According to Greenpeace: "Mature boreal forest contains 80 tons of carbon per hectare, and much more in the soil, all of which is released when the trees are cut."

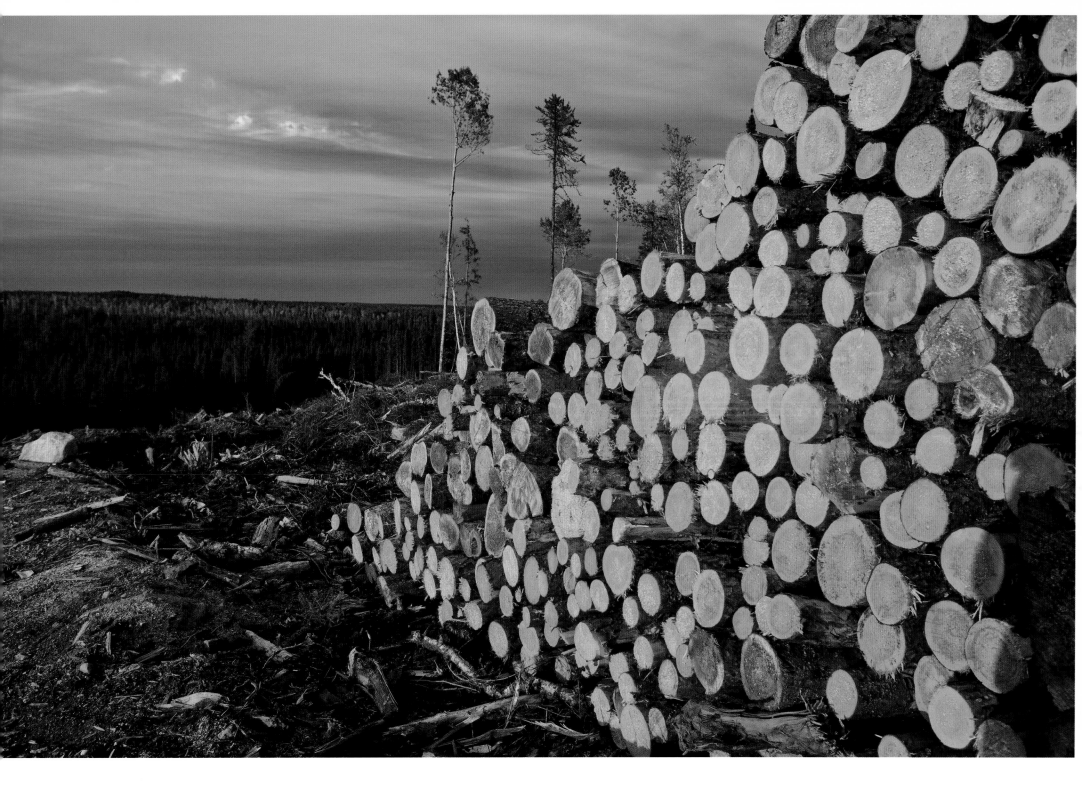

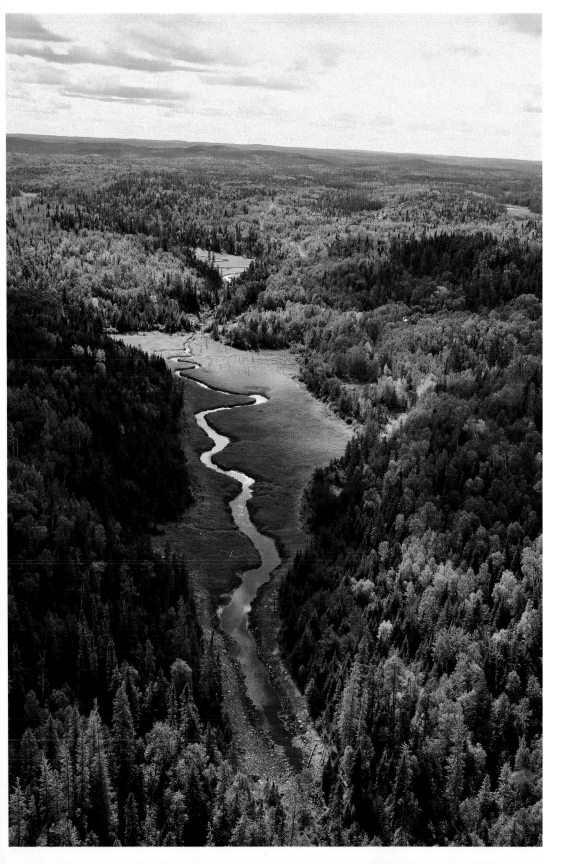

Kenogami Forest, Ontario, Canada.
< Environmentally sensitive riparian areas, permanent homes for moose, waterfowl, and other wildlife, are common features in the boreal landscape. More than 45 percent, or 154 million hectares (382 million acres), of the treed area of the boreal is under license to logging companies.

> A logging road, fringed with harvested trees (conifers and aspen), ready for processing.

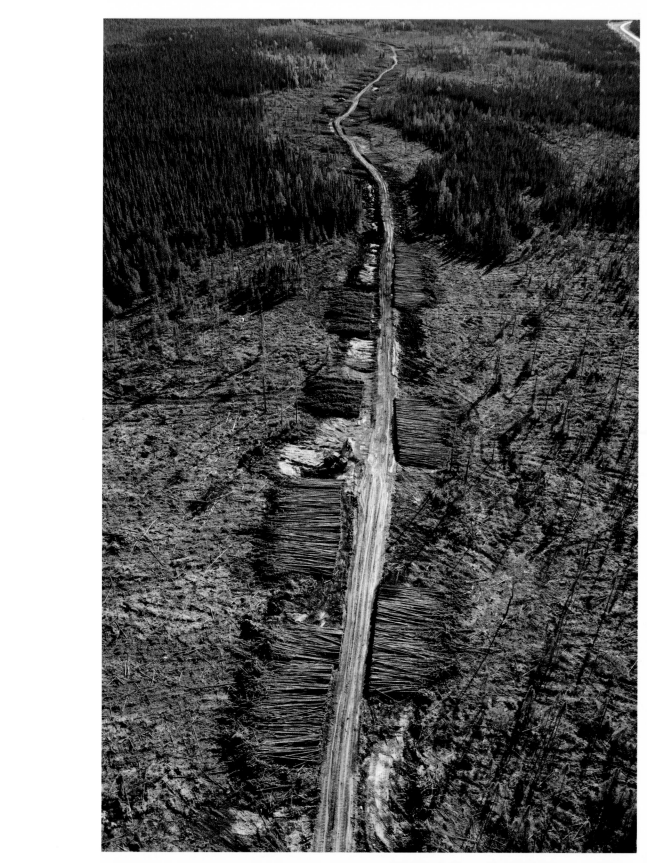

LIFE IS GOD'S MASTERPIECE

Nature is God's masterpiece. We have an ethical obligation to protect it and self-interest in doing so. Shouldn't we do all we can to protect the organism that gives us air to breathe and water to drink?

Since my early childhood the fragility and sanctity of life, its uniqueness, has been particularly notable to me. Indeed, life is among the most rare phenomena in the universe. Humanity has not found life anywhere other than here on Earth, in the biosphere surrounding our planet. The biosphere stretches from the top of the atmosphere, about three miles up, to the depths of the oceans, about two miles down. The totality of life that we have been able to find in the known universe exists within this tiny, five-mile band. Our daunting task in the 21st century is nothing less than the preservation of the functional integrity of this biosphere, on which all life depends.

Long before I evolved into my profession, as a child and during my early adulthood I became intimately aware of the suffering and destruction that misguided human behavior can cause. I learned early how disrespectful of life humans can be. My father spent the years 1939-1944 in Auschwitz. His first wife, his two children, both his parents, and six brothers and sisters were murdered by Nazis. My mother spent the years 1941-1944 in the Dachau concentration camp. Her first child (a daughter), her first husband, both her parents, and four brothers and sisters were also murdered by Nazis. They met and fell in love after the war as refugees at the Feldafing displaced persons camp. From my parents I learned the Talmudic lesson that life is God's masterpiece. Protecting life, especially its most vulnerable and rare expressions, is a motivation indelibly imprinted into my soul.

I am never emotionally far away from my parents' story, and today I join with others who are focused on preventing a different, newer form of refugee from emerging: environmental refugees. The U.N. estimates that during the next 40 years one billion new environmental refugees will emerge, growing from 155 million environmental refugees worldwide today. People will lose their homes to drought, flooding, coastal erosion, famine. As a result of anticipated effects of global warming, people in regions throughout the world are developing evacuation routes from places they have long

called their home. As Al Gore pointed out in his Nobel Prize acceptance speech, forced migrations of people with different religions and cultures and traditions, imposed largely by the effects of climate change in the form of floods, water scarcity, droughts, coastal erosion, famine, and damage to infrastructure from monster storms such as Hurricane Katrina, hold the potential to dwarf the forced human migrations caused by wars, and are now some of the most urgent threats facing poor people in the developing world. Movements of refugees at that scale are unprecedented and hold the potential to destabilize entire regions. The Pentagon has already been developing plans to address climate induced wars, anticipating frightening scenarios of migration, such as millions of Chinese fleeing a drought, trying to flood into Russia across the longest and most militarized border on the planet.

Every day more than 200,000 new people are born. Every six weeks, another New York City's worth of population is added to the planet. And people are consuming more, not less. Per-capita personal consumption and government consumption are both growing rapidly. The use of fossil fuels continues to rise, and people throughout the world are eating more meat, the production of which is certainly among the most ecologically destructive activities on Earth.

How can we make the shift to a saner form of living on Earth? Can we do so at all? Will more and more of the planet be converted into one of Henry Fair's "Industrial Scars"? The ecological crises we face are not the result of one single bad actor. The 90 million tons of global warming pollution emitted each and every day result from millions of purchasing and personal decisions made each day by literally billions of people and millions of companies. There is no single remedy for global warming, nor is there one remedy to address water scarcity or biodiversity loss. All actors in our society must do...something.

Perhaps many of these problems are not solvable. Perhaps. But when I move on and appear before my maker I don't expect Her to ask me, "Did you stop global warming?" or, "Did you prevent another Holocaust?" I expect Her to ask, "What did you try to do?"

Allen Hershkowitz
New York City, 2010

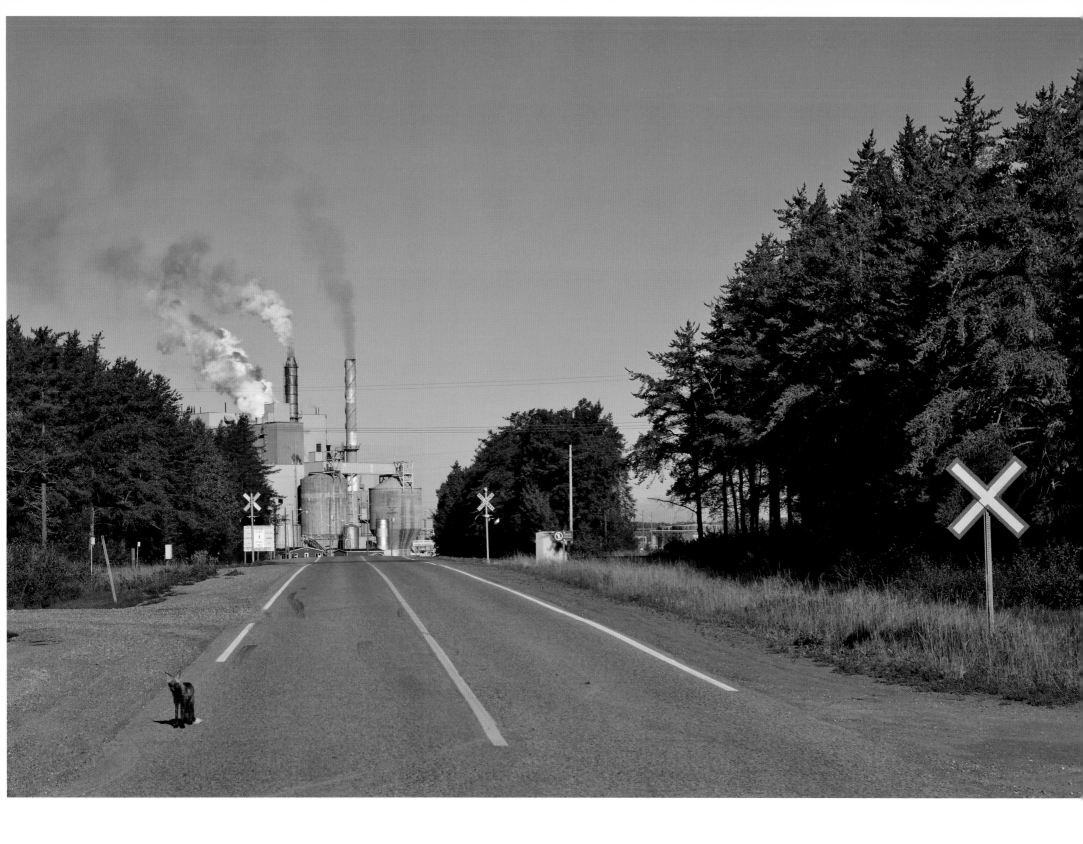

Terrace Bay, Ontario, Canada.
A red fox stands on the road to a pulp
mill. Smaller predators are often more
able to adapt to the disruptions caused
by human industrial processes.

Terrace Bay, Ontario, Canada.
This aeration pond is part of the
effluent treatment system. The primary
task of the treatment is to remove
organics (wood fiber), from the water
before it is returned to its source
(typically a river.)

The average pulp mill requires more than
16 million gallons of fresh water daily.

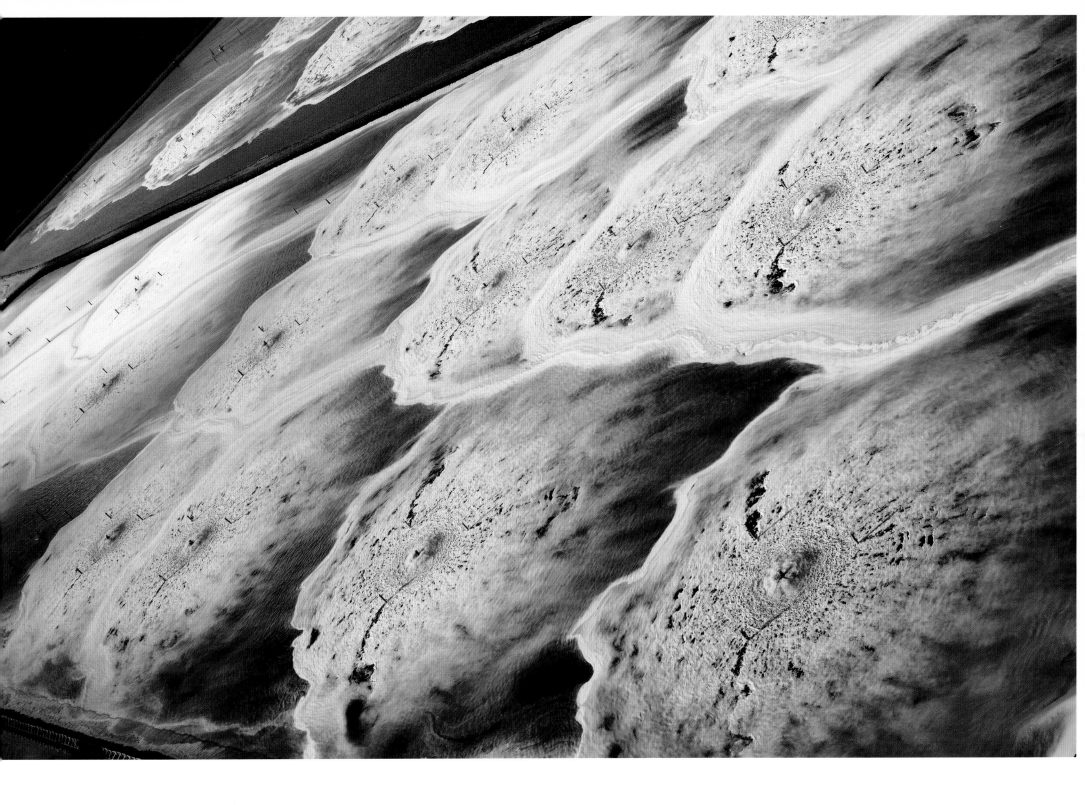

Terrace Bay, Ontario, Canada.
At this factory, the pulp for the world's most popular facial tissue is produced. If every household in the United States replaced just one roll of virgin-fiber toilet paper with a roll of 100 percent recycled paper, we could save 423,900 trees.

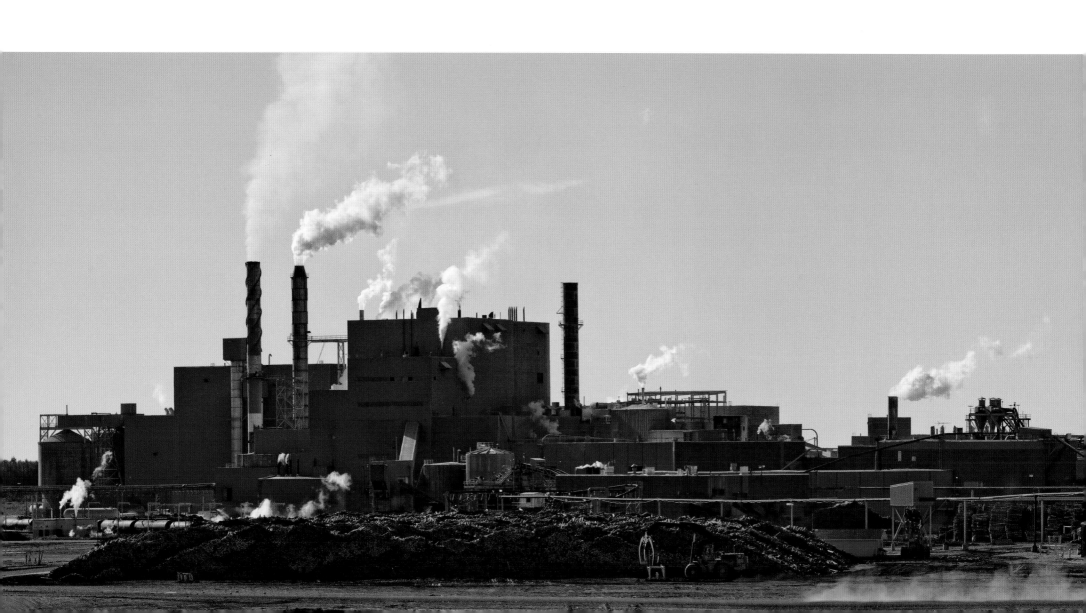

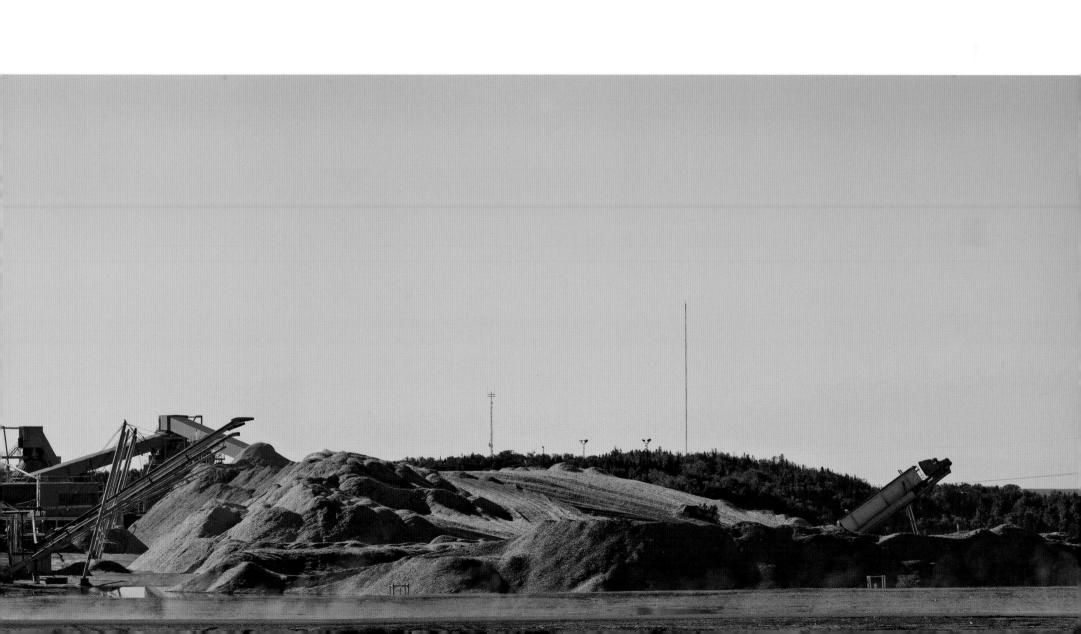

TURN·OFF THE LIGHTS

The USA gets about 50 percent of its electricity by burning coal, a power source billed as "cheap energy." Ironically, the label only applies if one does not include the subsidies given to coal producers and the power utilities that supply and use this dirtiest of fuels. It is "cheap" on our electricity bills only because we paid for it in advance with our tax dollars.

Coal combustion is the largest single source of climate-changing gases being released into the environment, as well as the largest source of mercury, arsenic, and uranium. But the environmental problems begin as soon as coal is exposed. In the mountainous Appalachian Region, the traditional (quite dangerous) deep-mining methods have been replace by a uniquely American approach called mountaintop removal mining (MTR), in which the mountain is blasted away and the coal collected, leaving only a decimated ecosystem that will never recover.

MTR is a perfect example of the false claim that environmental devastation is necessary for job creation. According to one estimate, West Virginia had 120,000 coal-mining jobs in 1960 (before the adoption of MTR), and 15,000 in 2002. The story of Coal River Mountain is particularly illustrative: though permits have been issued to destroy the mountain for coal, which would provide a few jobs and enough coal for a short time, studies have shown that windmills in the same area could effectively provide electricity forever. Regulators went ahead and issued the permits for blasting to begin in spite of overwhelming local support for the wind farm option.

The people living in the areas of these various resource extractions are the first to be impacted by these processes, and some become activists in self-defense. One such hero is a man named Larry Gibson, and I was lucky enough to have him as a guide. Larry lives on Kayford Mountain (or what's left of it), and is a modern-day David standing up to the Goliath of "King Coal," vowing to protect his ancestral land from destruction. It's an ironic comment on human nature that, though the number of coal mining jobs has plummeted, people in the area still fiercely advocate for the industry in spite of the fact that the natural systems that support life in the region are being destroyed. As you might guess, Larry is not the most popular kid on the block, having suffered threats, violence, and the killing of a dog. But he is a man of mettle, and a source of inspiration.

Formerly Kayford Mountain, West Virginia.
The location of a coal seam is deter-
mined by taking "core samples." In the
mountaintop removal (MTR) mining pro-
cess, the earth is then blasted away
to reach the coal seam, a process that
wastes 94 percent of the coal.

Near Kayford Mountain, West Virginia. The bowl shape of this excavation suggests that it might be used to contain coal slurry, the mixture of water and chemicals used to wash coal.

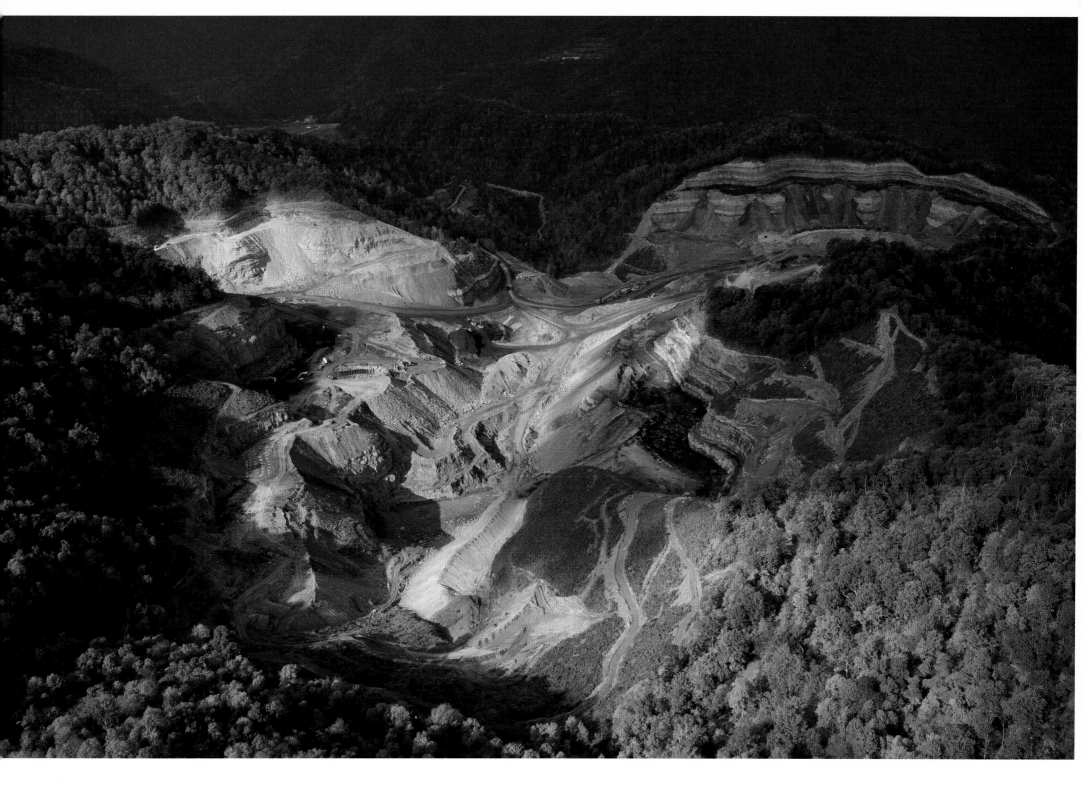

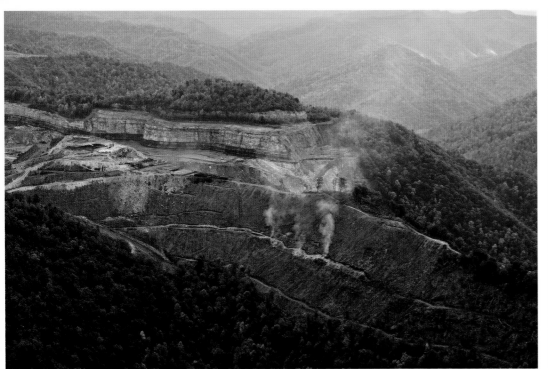
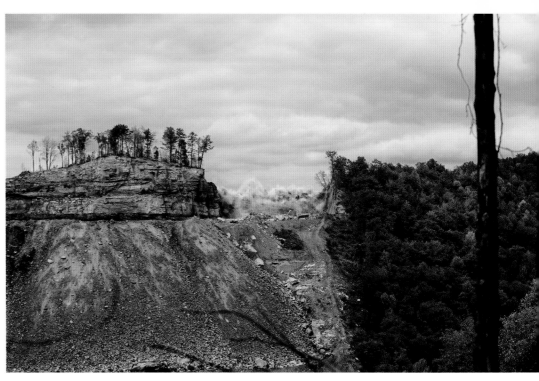

Kayford Mountain, West Virginia.
Mountaintop removal in Appalachia begins with
the clearing and burning of the old-growth
forest. The earth is blasted away to reach
the coal, and then dumped in the next valley,
inevitably covering the stream flowing there.
To date, more than 500 mountains have been
destroyed, and 1200 miles of streams buried
in the MTR process.

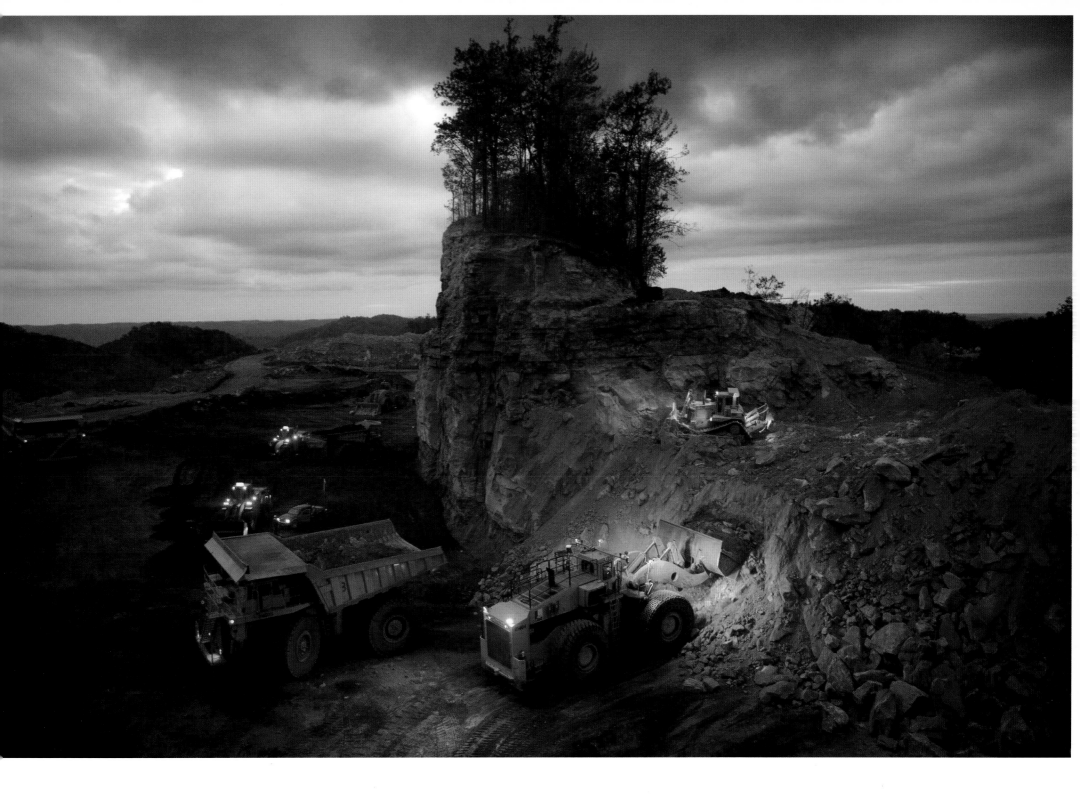

"How did you become an activist?" I was surprised by the question. I never considered myself an activist. I am a slow-paced, taciturn scientist from the Midwest. Most of my relatives are pretty conservative. I can imagine attitudes at home toward "activists."

I was about to protest the characterization — but I had been arrested, more than once. And I had testified in defense of others who had broken the law. Sure, we only meant to draw attention to problems of continued fossil fuel addiction. But weren't there other ways to do that in a democracy? How had I been sucked into becoming an "activist?"

My grandchildren had a lot to do with it. It happened step-by-step. First, in 2004, I broke a 15-year, self-imposed effort to stay out of the media. I gave a public lecture, backed by scientific papers, showing the need to slow greenhouse gas emissions — and I criticized the Bush administration for lack of appropriate policies. My grandchildren came into the talk only as props — holding one-watt Christmas tree bulbs to help explain climate forcings.

Fourteen months later I gave another public talk — connecting the dots from global warming, to policy implications, to criticisms of the fossil fuel industry for promoting misinformation. This time my grandchildren provided rationalization for a talk likely to draw administration ire: I explained that I did not want my children to look back and say, "Opa understood what was happening, but he never made it clear."

What has become clear is that our planet is close to climate tipping points. Ice is melting in the Arctic, on Greenland and Antarctica, and on mountain glaciers worldwide. Many species are stressed by environmental destruction and climate change. Continuing fossil fuel emissions, if unabated, will cause sea level rise and species extinction accelerating out of humanity's control. Increasing atmospheric water vapor is already magnifying climate extremes, increasing overall precipitation, causing greater floods and stronger storms.

Stabilizing climate requires restoring our planet's energy balance. The physics are straightforward. The effect of increasing carbon dioxide on Earth's energy imbalance is confirmed by precise measurements of ocean heat gain. The principal implication is defined by the geophysics, by the size of fossil fuel reservoirs. Simply put, there is a limit on how much carbon dioxide we can pour into the atmosphere. We cannot burn all fossil fuels. Specifically, we must (1) phase out coal use rapidly, (2) leave tar sands in the ground, and (3) not go after the last drops of oil.

Actions needed for the world to move on to clean energies of the future are feasible. The actions could restore clean air and water globally, assuring intergenerational equity by preserving creation — the natural world. But the actions are not happening.

At first I thought it was poor communication. Scientists must not have made the story clear enough to world leaders. Surely there must be some nations that could understand the intergenerational injustice of present energy policies.

So I wrote letters to national leaders and visited more than half a dozen nations, as described in my book, *Storms of My Grandchildren*. What I found in each case was *greenwash* — a pretense of concern about climate, but policies dictated by fossil fuel special interests.

The situation is epitomized by my recent trip to Norway. I hoped that Norway, because of its history of environmentalism, might be able to stand tall among nations, take real action to address climate change, drawing attention to the hypocrisy in the words and pseudo-actions of other nations.

So I wrote a letter to the Prime Minister suggesting that Norway, as majority owner of Statoil, should intervene in its plans to develop the tar sands of Canada. I received a polite response, by letter, from the Deputy Minister of Petroleum and Energy. The government position is that the tar sands investment is "a commercial decision," that the government should not interfere, and that a "vast majority in the Norwegian parliament" agrees that this constitutes "good corporate governance." The Deputy Minister concluded his letter, "I can however assure you that we will continue our offensive stance on climate change issues both at home and abroad."

A Norwegian grandfather, upon reading the Deputy Minister's letter, quoted Saint Augustine: "Hypocrisy is the tribute that vice pays to virtue."

The Norwegian government's position is a staggering reaffirmation of the global situation: even the greenest governments find it too inconvenient to address the implication of scientific facts.

It becomes clear that needed actions will happen only if the public, somehow, becomes forcefully involved. One way that citizens can help is by blocking coal plants, tar sands, and mining the last drops of fossil fuels from public and pristine lands and the deep ocean.

However, fossil fuel addiction can be solved only when we recognize an economic law as certain as the law of gravity: as long as fossil fuels are the cheapest energy they will be used. Solution therefore requires a rising fee on oil, gas, and coal — a carbon fee collected from fossil fuel companies at the domestic mine or port of entry. All funds collected should be distributed to the public on a per-capita basis to allow lifestyle adjustments and spur clean energy innovations. As the fee rises, fossil fuels will be phased out, replaced by carbon-free energy and efficiency.

A carbon fee is the only realistic path to global action. China and India will not accept caps, but they need a carbon fee to spur clean energy and avoid fossil fuel addiction.

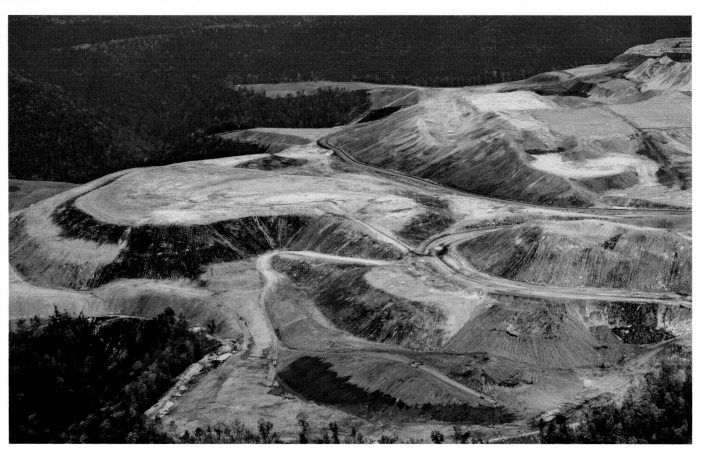

Near Kayford Mountain, West Virginia.
After the old-growth forest has been cut and burned, the mountain removed, and the coal extracted, the only "remediation" required of the mining companies is the planting of grass over the site. This is done via hydro-seeding in which a fast growing (and short-lived) grass seed mixed with fertilizer is sprayed over the site.

(< and page 83)

Governments today, instead, talk of "cap-and-trade-with-offsets," a system rigged by big banks and fossil fuel interests. Cap-and-trade invites corruption. Worse, it is ineffectual, assuring continued fossil fuel addiction to the last drop and environmental catastrophe.

Stabilizing climate is a moral issue, a matter of intergenerational justice. Young people, and older people who support the young and the other species on the planet, must unite in demanding an effective approach that preserves our planet.

Because the executive and legislative branches of our governments turn a deaf ear to the science, the judicial branch may provide the best opportunity to redress the situation. Our governments have a fiduciary responsibility to protect the rights of young people and future generations.

To the young people I say: stand up for your rights — demand that the government be honest and address the consequences of their policies. To the old people I say: let us gird up our loins and fight on the side of young people for protection of the world they will inherit.

I look forward to standing with young people and their supporters, helping them develop their case, as they demand their proper due and fight for nature and their future. I guess that makes me an activist.

James Hansen
Whitesville, WV, 2010

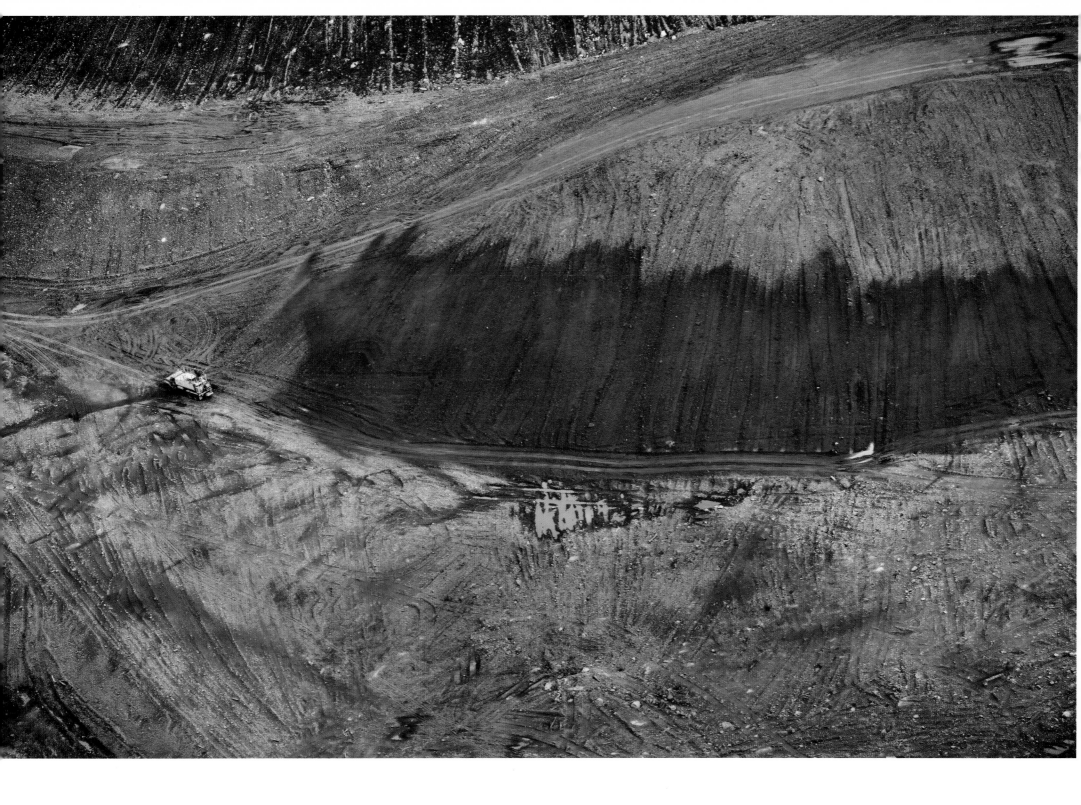

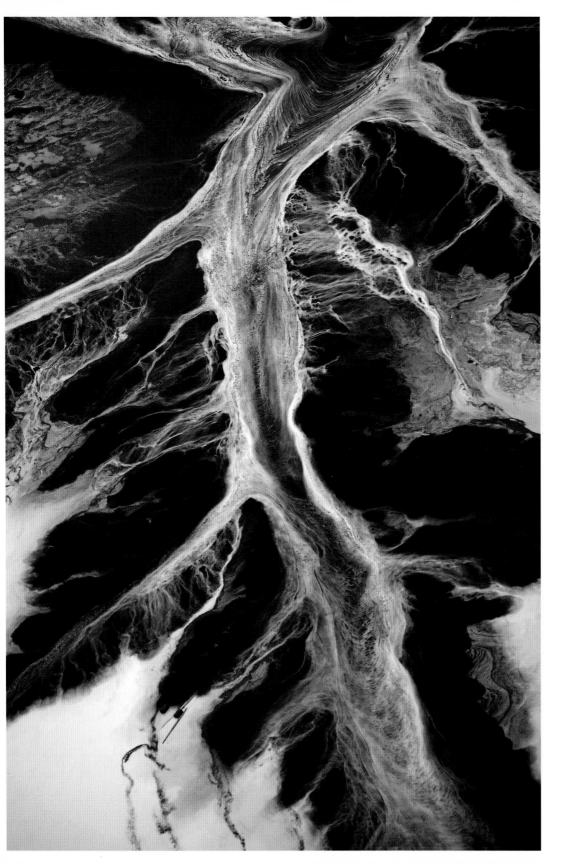

Coal River Mountain, West Virginia.
After mining, coal must be processed with tremendous amounts of water and chemicals (many of which are known toxicants). This mixture, along with the accumulated residue from the coal washed, is called slurry and is stored in valleys impounded by earthen dams that fail with disturbing frequency. In February 1972, a slurry impoundment in Buffalo Creek, West Virginia burst, killing 125 people and leaving 4,000 homeless.

AFTER KATRINA

Hurricane Katrina was a turning point for the U.S. in many ways. However, its exposure of the racial divide and the true nature of the corrupt administration running our country at the time is a fascinating topic for another writer. A different aspect of the story is the effect of extreme weather events on the industry in "Cancer Alley," with its miles of pipelines and innumerable open waste pits filled with seemingly infinite varieties of toxic compounds. The impact of the tremendous power contained in that storm on the infrastructure and surrounding (mostly poor) communities was a topic of great interest to me, so I decided to spend Christmas 2005 investigating.

New Orleans is one of the most interesting cities in the USA, with its mixture of races, music, food, and the Southern flavor — all with a cosmopolitan sophistication. By Christmas, most major news outlets had decided there was nothing left to report, so the city was no longer overrun with hungry journalists, leaving only the few remaining or returning residents and tired relief workers. This also meant that the services I would need (a hotel room, a plane for charter) would be available for a reasonable rate.

Barataria Bay, Louisiana.
Buried 150 feet below the Mississippi Delta, covered with marsh and quicksand, The Grande Ecaille sulphur mine was known as "the mine that couldn't be built." The mosquitoes were so bad that airplane engines were brought in to keep them at bay. These pilings are the remains of a wharf built as a transit point between the Mississippi River and a 10-mile canal carved through the marsh to the mine.

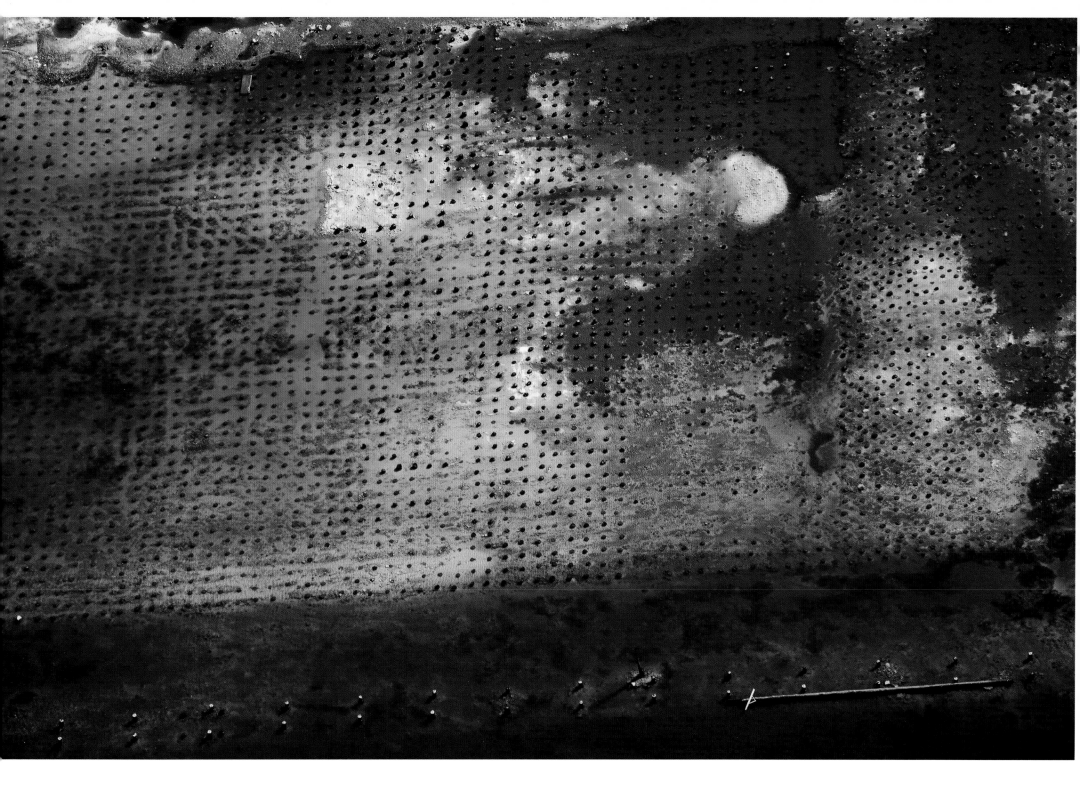

Gramercy, Louisiana.
The wind spreads dust from the residual
waste of the aluminum smelting process
far and wide, coating and coloring
everything a brick red. The many con-
taminants are similarly dispersed, lead
being one of the most insidious.

Gramercy, Louisiana.
Waste from a sugar mill is aerated.

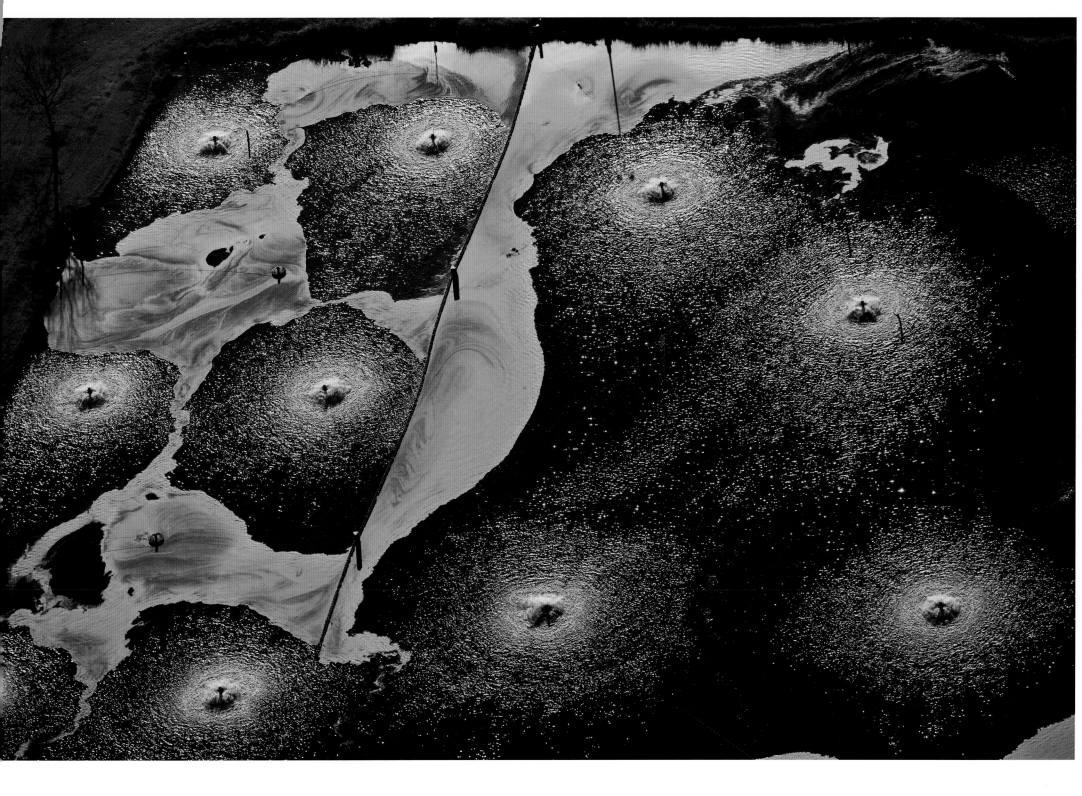

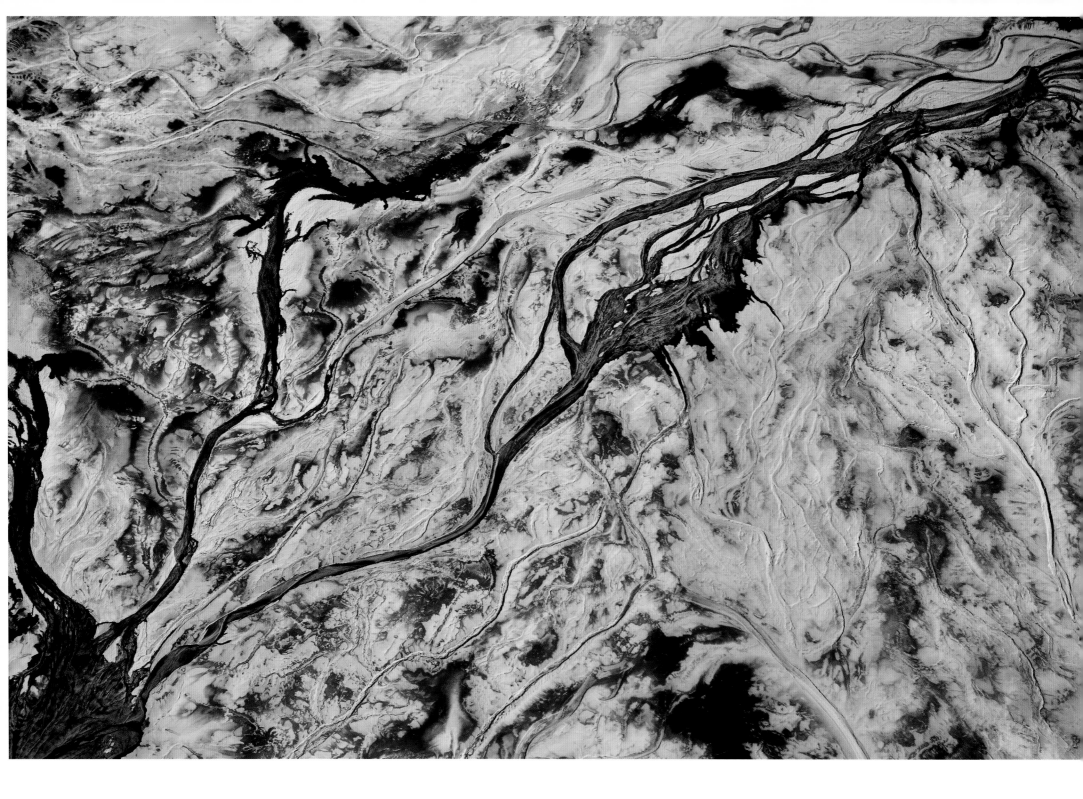

Uncle Sam, Louisiana.
The ability to fertilize plants by synthesizing the three essential macro-nutrients enabled the industrial agri-cultural revolution and the concurrent human population explosion. The waste generated in production of the phosphate component is copious and extremely toxic.

Convent, Louisiana.
Unknown waste at refinery.

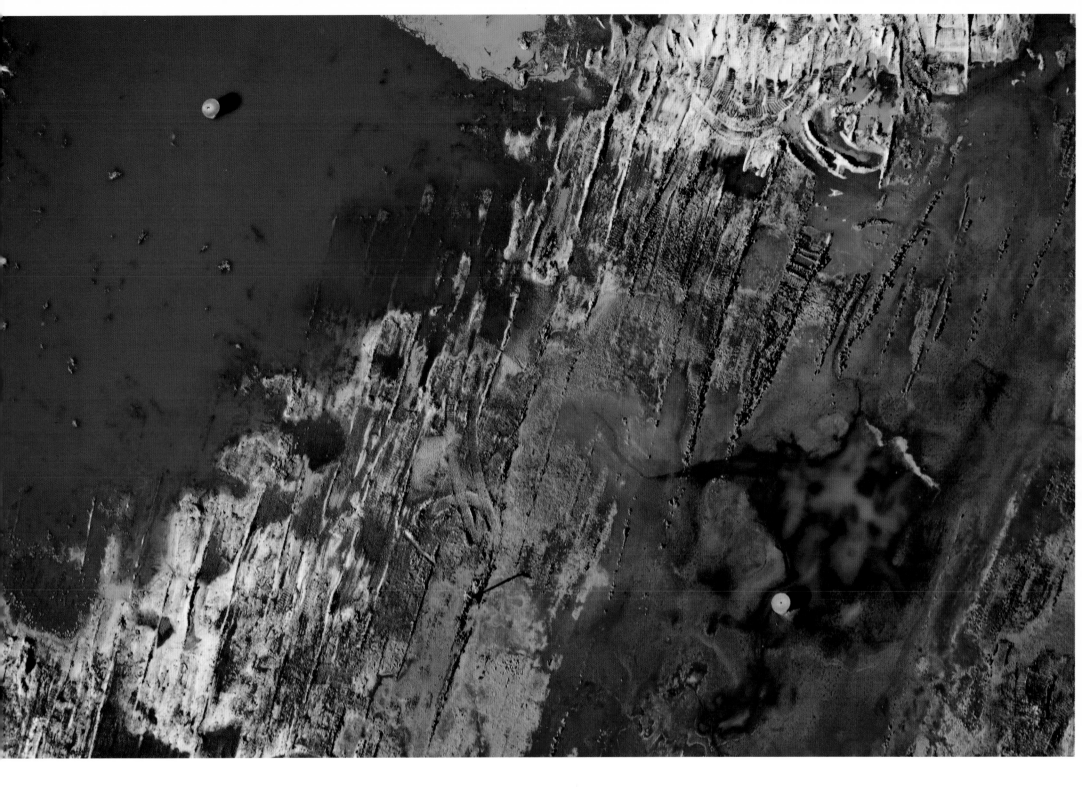

Yesterday my youngest son told me that sometimes he hates people. That got my attention. I asked him why and he informed me that people have destroyed too many habitats for animals. If he only knew. But he does not really know, because I shelter him from the full force of the devastation that we daily wreak on the lands and seas over which we pretend to exercise dominion. He does watch television, especially what he calls "nonfiction" television, though the purported documentary programs he studies with his avid eight-year-old's intensity on Animal Planet and Discovery often strike me as being every bit as contrived and concocted as Man vs. Wild, with the ludicrous Bear Grylls. From his beloved animal shows and his growing collection of precious animal books he has discerned the obvious, that we are steadily murdering every last delicate creature on this increasingly brown and oily planet. Yet we forbid him from watching the news and we do not listen to NPR in his presence, because the horror of that endless narrative of woe we call news does not lead to wisdom but to madness, the madness of acceptance and indifference and acquiescence. He does not really even know much about the unfurling horror in the Gulf of Mexico, as millions of gallons of oil and methane spew with uncontainable force into that fragile and bruise-blue sea.

When my oldest son was about three, we watched him one fine summer day as he scoured a green, grassy lawn along the Atlantic shore in Maine, filling large glass jars with slugs. His hands were covered with slime so viscous and sticky that we despaired of cleaning it off. His grandfather was soon to mow that yard, and my little boy feared for the lives of slugs. "I feel kindly toward all creatures," he told me, unwittingly paraphrasing the Enlightened One. He told me that slugs hug each other with their eyes.

Although my oldest boy has grown and matured and lost some of the intensity of his passion for the slimy invertebrates of innocent childhood, my youngest still thinks and talks about animals from the moment he wakes up until he goes to sleep surrounded by his stuffed cheetahs, white tigers large and small, a plastic snow leopard, a precious polar bear named Poley. His attraction to and identification with polar bears was once so intense that for years he confidently asserted to anyone who inquired that, yes, he was in fact a polar bear cub.

Caracals and jaguarundis, margays and servals, binturongs, kinkajous, sun bears, aardwolves, and the Spanish lynx all populate his imagination. He tells me how many elephants still live in China, and gives me a physiological explanation for why the clouded leopard is able to leap so high and so far. Did you know they love to eat fire cats, as red pandas are also called? Cheetahs in Afghanistan and Iran are objects of

his special concern, as are Siberian tigers and the prospects of the African golden cat. Mountain lions are especially wonderful and mysterious in his eyes; he knows for a fact that the eastern mountain lion is alive and well, and by the way did you know that wolves still haunt the Maine woods? All predators are dear to him, and he has predatory ambitions of his own — which might explain his curiosity about ungulates with both even and odd toes. Recently I sat down at my computer and discovered on the screen a page of search results on the terms "toy elk." Indeed, if I let him he would probably spend his afternoons watching little but hunting and fishing programs; he covets the intensity of their seeming reality, the interactions of men and women, and even children (especially those austere and primitive hunters who go armed with bow and arrow), with the wild spirits of the animals which they stalk and kill. He interrogates me with questions about the hunting I did growing up in Texas, how many deer, how many javelinas, how many varmints did I shoot. And what is a varmint anyway? Is a raccoon a varmint? Yes. What about a beaver? No. And did I ever see a mountain lion? What about a jaguar? Or an ocelot? His books have shown him that those beautiful cats once ranged as far north as the Rio Grande valley.

Is there a contradiction in this ardor for animals that cohabits so comfortably with the instinct for hunting and killing? He once asked me that question himself, in his own way. I think not. What is more surprising is that we can be an animal capable of both worshiping the souls of other animals and through our carelessness and waste, of destroying their world with such thoughtless abandon. Our species is the progeny of predators, whether we wish to believe it or not, and from this inheritance, I believe, arises a child's natural and fierce affinity for all big cats, wolves, coyotes, foxes, bears, and wolverines. The predatory instinct that so alarms the soft and gentle and civilized saints who populate our cities is not a curse. It is, I believe, the blessing of our hunter's nature that makes some of us feel so tenderly toward all creatures. The authentic hunter is not cruel but loves and cherishes his prey; he keeps it and preserves it and if he has been taught well takes only what he needs. Alas, it is the farmer and householder in us that makes us wish to exterminate the brutes who dig in our flowerpots and gardens. War no doubt springs eternal, yet it was from agriculture that we grew commerce and leisure and the lust for abstractions and ever more terrible wars. And so we begin as innocent Buddhists, grow into fierce shamanistic hunters, and, if we do not perish in some futile crusade, end our days as alienated metaphysicians, calculating our profits and losses while contemplating the meaning of tragedy as all life and beauty perish around us.

Roger D. Hodge
New York City, 2010

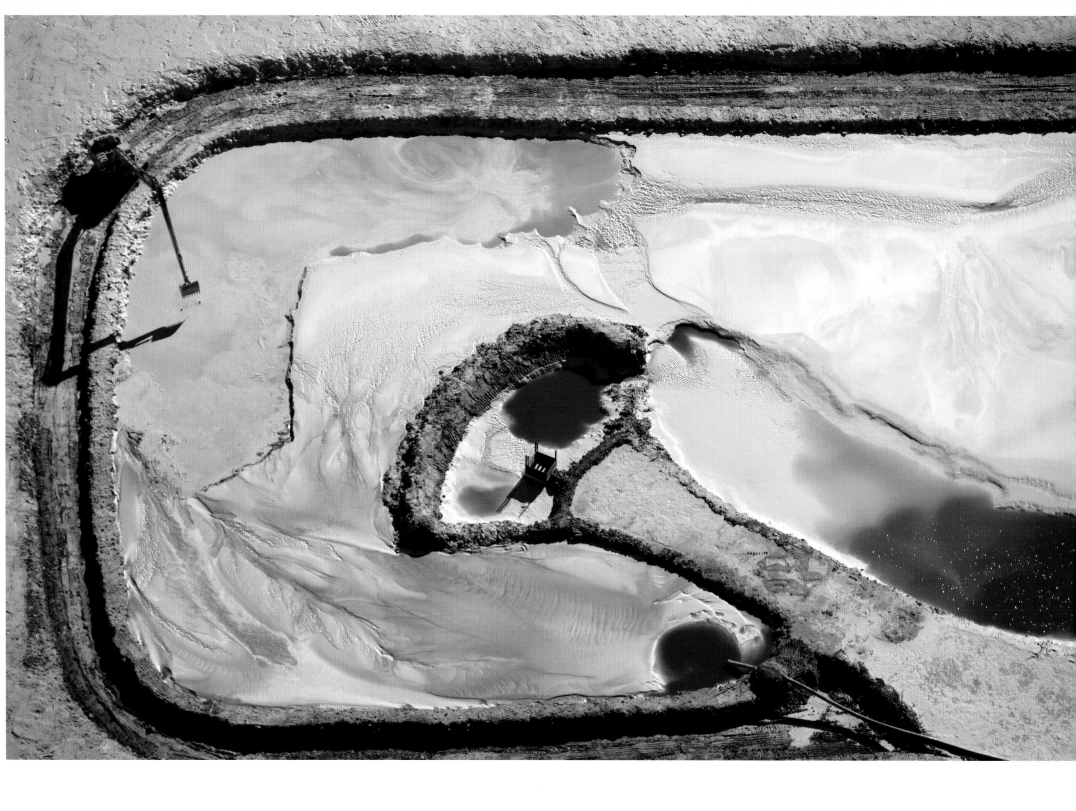

Geismar, Louisiana.

An excavator removes solids from the effluent pumped into the impoundment at this chemical plant, spreading them on the dike to increase its height, and thus capacity. The principal product of this plant, hydrofluoric acid, is the essential building block of refrigerants and propellants, and is a major ozone depleter and global warming contributor.

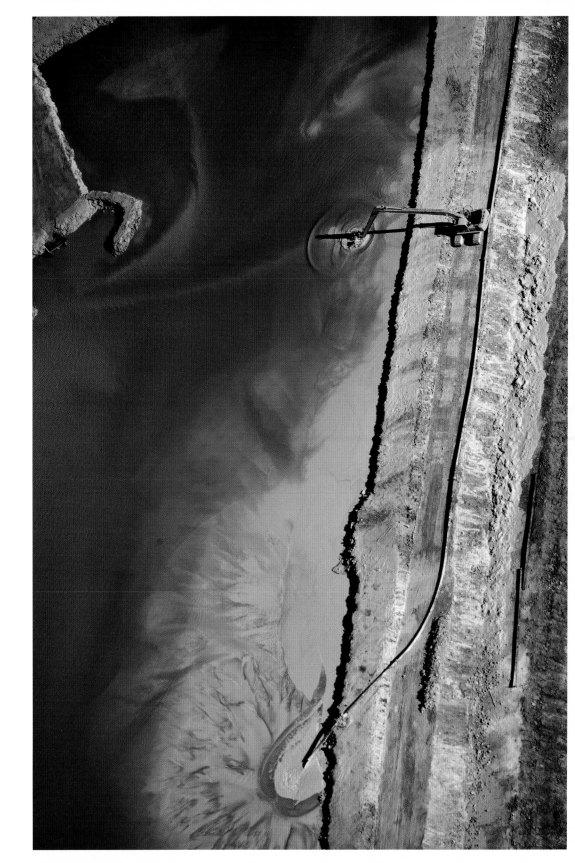

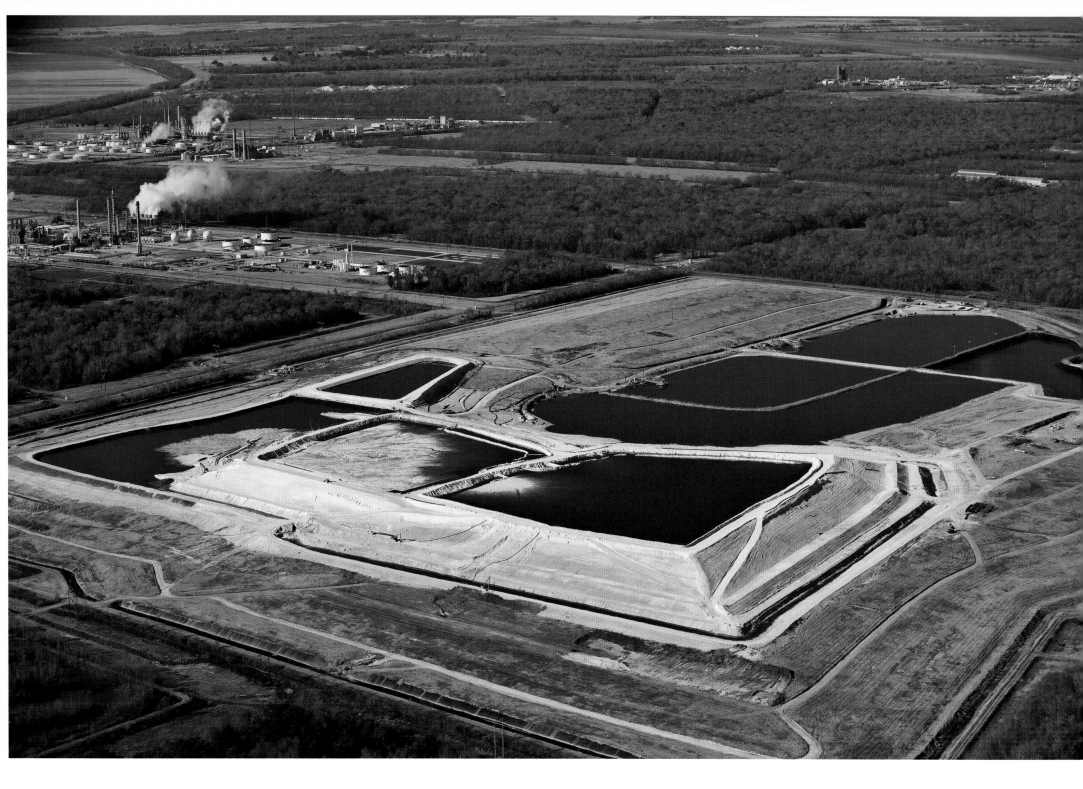

Geismar, Louisiana.
Effluents from fertilizer production are
pumped into this "gyp stack." The solid
gypsum is scooped out by excavators be-
fore it hardens, and is spread on the
"impoundment" to build it up and allow
for higher capacity. This solution is
gypsum, sulfuric acid, and an assortment
of heavy metals, including uranium and
radium. As a result of the RCRA (Resource
Conservation and Recovery Act) amend-
ments, these pollutants are not reported.

(opposite page, and pages 104-07)

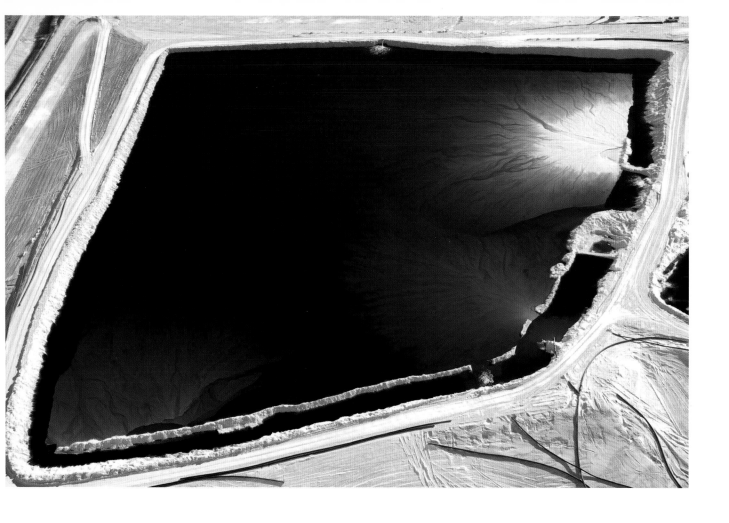

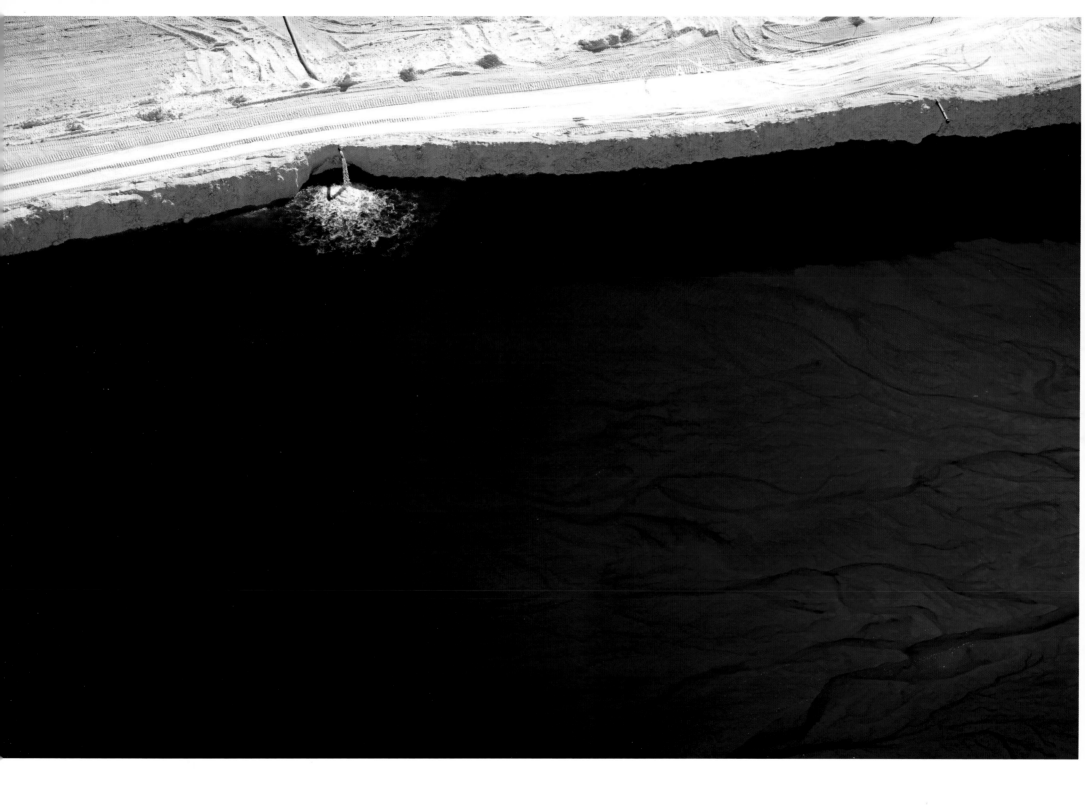

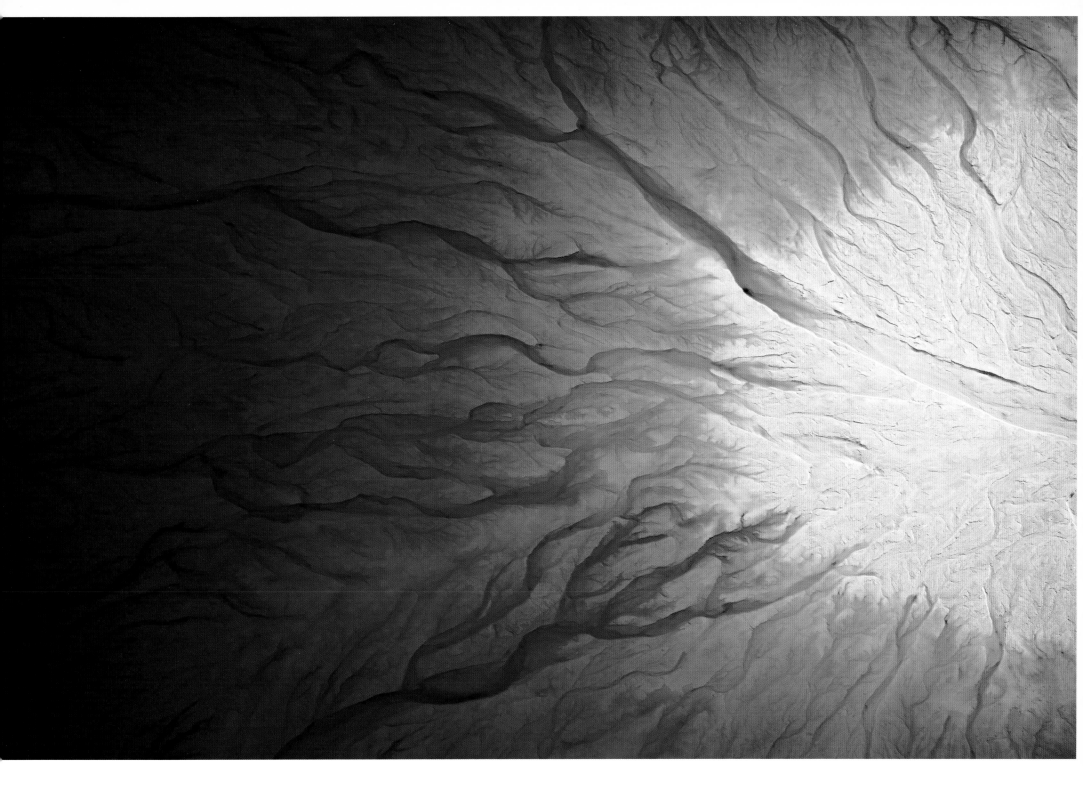

Children are natural Puritans when it comes to nature. They suspect right away that the outdoors is scary, unpredictable, and dangerous. The founding pilgrims saw the New World's forest this way — as a dark haven of demons and satanic monsters — all the more reason why clear-cutting in pioneer days was praised as God's work. Children know from fairy tales that the woods are forbidding and evil, but also from practical experience. A deer might be sweet looking as a cartoon or from a car window. But up close, unexpectedly, they are as terrifying as a charging boar or a hissing snake. Kids realize they are constantly getting propagandized by claims of lovely scenery and Saturday morning shows with anthropomorphized critters. They begin life, like Woody Allen, "at two with nature."

But eventually the romantic view begins to kick in and the perilous monstrosities of mountain ranges and fatal intimations of swollen rivers take on a distant loveliness, becoming havens of beauty and grottoes of powerful emotion recalled in tranquility. I grew up in South Carolina where I learned to think that I had subdued Calvinist nature by hunting, boating, and camping. Of course, that sense is false and artificial, drilled into us by elders, and not at all, um, natural. We fool ourselves into thinking we can ever control or contain or even comprehend nature's power. No matter how great our arrogance, nature reminds us periodically that we are not at all in charge — whether it's the sight of a pristine village on a barrier island decimated by a seasonal hurricane or the ancient spangled choreography of a bullfight suddenly interrupted by a chaotic goring. When it comes to nature, our first impression was right on.

Still, that fiction of control is perhaps necessary. I have foolishly come to terms with the snakes, spiders, hornets, boars, foxes, coyotes, and bobcats that I've met in the woods. And I now show my kids these beasts when they appear and even say that they won't hurt you if you're not threatening their young (mostly true), and that in fact they are actually beautiful (true, but, like I say, a very acquired taste and view). That's all part of the post-romantic PR machine — a relatively new view of the world at large, on par with "children are innocent" and "old folks are wise." And yet, like most people, I both buy into it and at the same time continue to reserve a small dark corner of my nightmare world for that original and true understanding. Everybody does; mine involves bats.

Now, bat-loving types lecture people that bats are actually very clean animals and they eat half their weight in insects with each sunset, and they tell us it's a false slander that they get tangled in women's hair. "Batophilia" is not that uncommon these days, as evidenced by all the people heading into the flying mammals' very lairs: high-tech cave explorers armed with headlamps, special caving ropes, and the ability to use the word "spelunk" without laughing.

Back in the Stone Age when all outdoor equipment was bought at the Army Navy store, caving was a pastime for oddballs. I became one of those when, at age eight, my friend Donald and I were introduced to it by his grandmother who had a house in Sewanee, Tennessee. T-ma,

as the grande dame was known, was happy to share her equipment, mostly a pile of dented brass lanterns that dated, probably, from the Civil War. You filled the lantern's bottom with carbide and added water, and once it began to make a certain unmistakable sizzle, the resulting gas — as redolent as boiling ore — was flammable. Every summer for many years, Donald and I explored the underbelly of the Cumberland Plateau like antebellum miners.

In most Tennessee caves there are several fairly unavoidable features — the big cathedral space, the mud room, the fat man's squeeze (the latter being a tight limestone tunnel that could only be navigated in a sniper's crawl). On one occasion, Donald's father, a noted heart surgeon, was struggling through a fat man's squeeze. Dr. Eddie was bald, and every time he'd lift his head to peer forward, he'd howl as a tiny stalactite dart punctured his scalp. He exited looking like a middle-aged messiah who'd just removed a crown of thorns.

I was next in the squeeze, grinding on my elbows across a gravel floor made more comfortable by a frigid stream of cave water trickling through. The spare plastic bag of carbide I kept in my pants pocket had rubbed open from all the wiggling, and my hip began to sizzle, then to warm up, and finally to burn hot as fire. I'd begun to hump pretty damn fast, squirming in a panic, as my mind foresaw a suffocating gas buildup — or, more likely, a Jerry Bruckheimer-like explosion after a concerned Dr. Eddie bent down to shine his flame into the tunnel. "Hey, Jack, are you having any — " Boom!

Turns out there was a lot more air in the tunnel than I thought, because right then and there, a couple of cave bats decided to flutter through on their way out. The sudden chaos of fur — now that I think about it, there must have been at least 10 bats — encouraged me to discover the virgin pleasure of pressing one's face into icy gravel water. Fortunately, bats have that radar thing, so all 100 of them (now that I really think about it), easily found the space above my prostrate body, although it must have been difficult scrambling down my back given the vibrations caused by all the subaqueous screaming.

When I finally got out, everyone was tending to his own suffering. Dr. Eddie was stanching his head with a rag. No one cared about my encounter with a thousand bats. Donald's brother accused me of telling a fish story about the, obviously, tens of thousands of bats that attacked me. He said he'd only seen a couple of really tiny bats. I don't know. In my mind — then and now — my ordeal resembled that encyclopedia picture of Carlsbad Caverns at dusk when a million bats roar out like demonic nuncios in a funnel of black terror.

And yet, I continue to cave. Because I still find the great outdoors beautiful and because I have refined my fear of nature into a rarefied phobia, an exquisitely nuanced phobia. It's not truly activated unless I'm in a cave and I see a bunch of bats, and then my pants catch on fire.

Jack Hitt
New Haven, CT, 2010

Darrow, Louisiana.
Tremendous amounts of "red mud" bauxite waste are produced through the smelting of aluminum, (which contains many contaminants, heavy metals, and impurities). It is pumped into vast storage "impoundments" and allowed to settle. Once dry, the dust is blown by the wind, dispersing the contaminants and covering everything nearby. The machine tracks seem to be the result of a raking process, possibly to separate solids from the water, the mixing of which would be the result of the heavy rains from Katrina.

(opposite page, and pages 113-15)

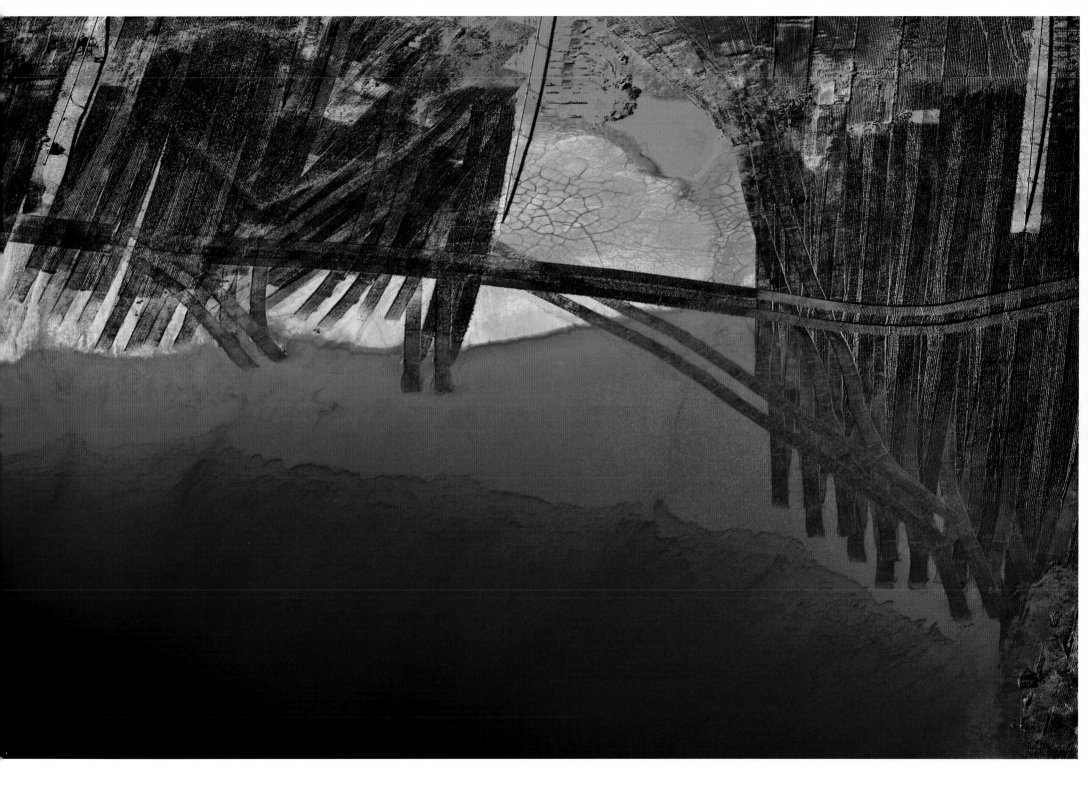

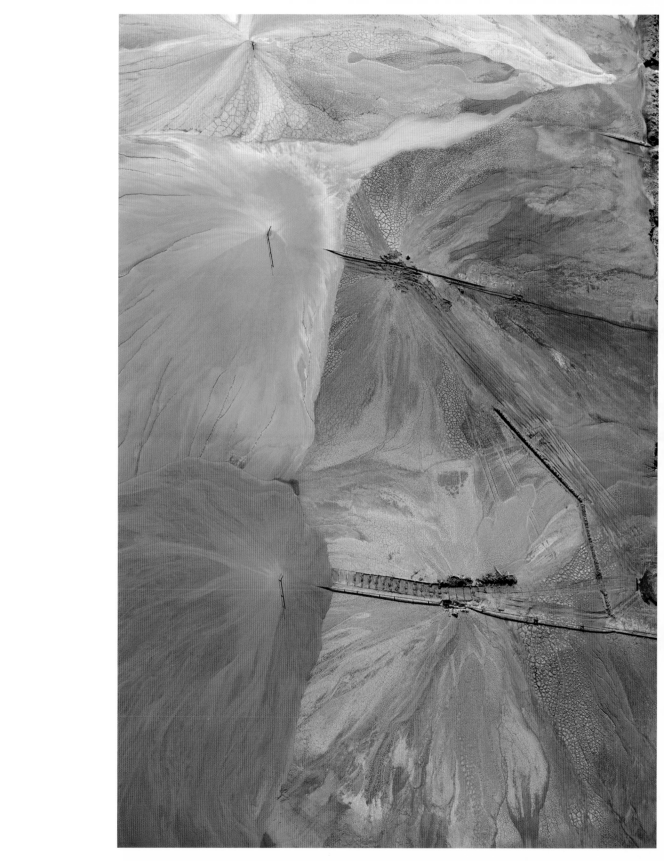

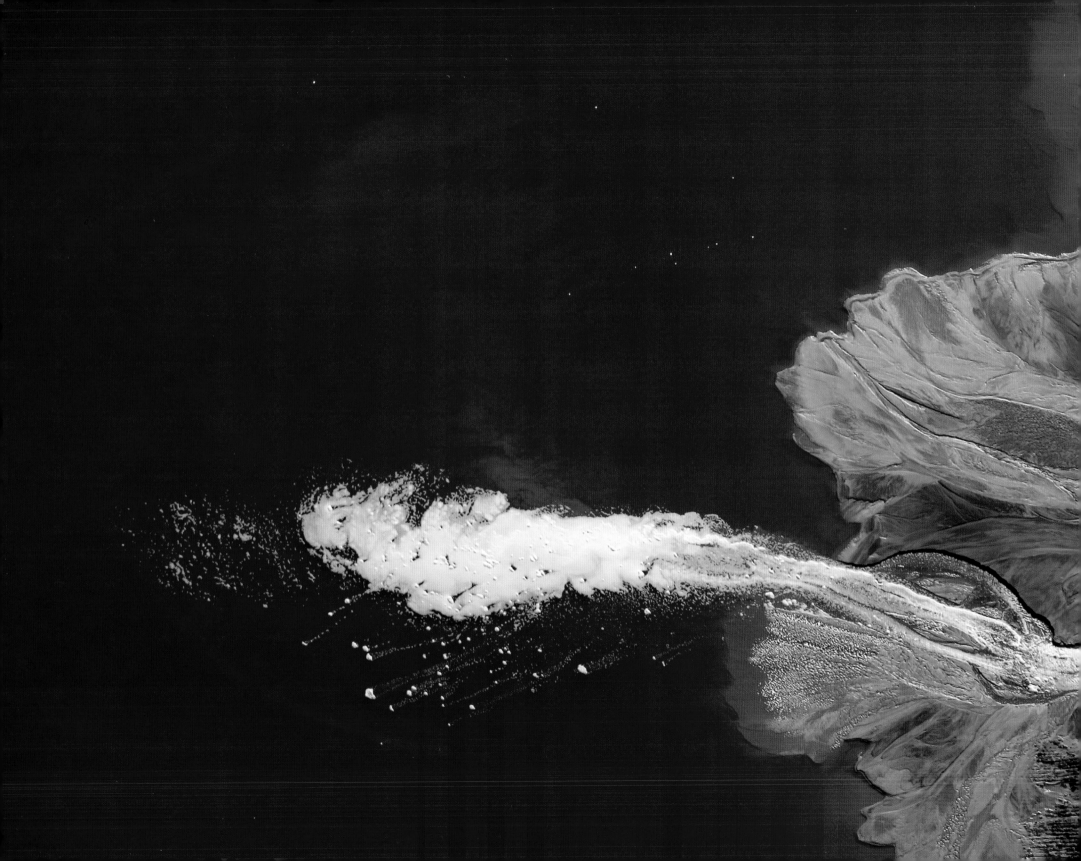

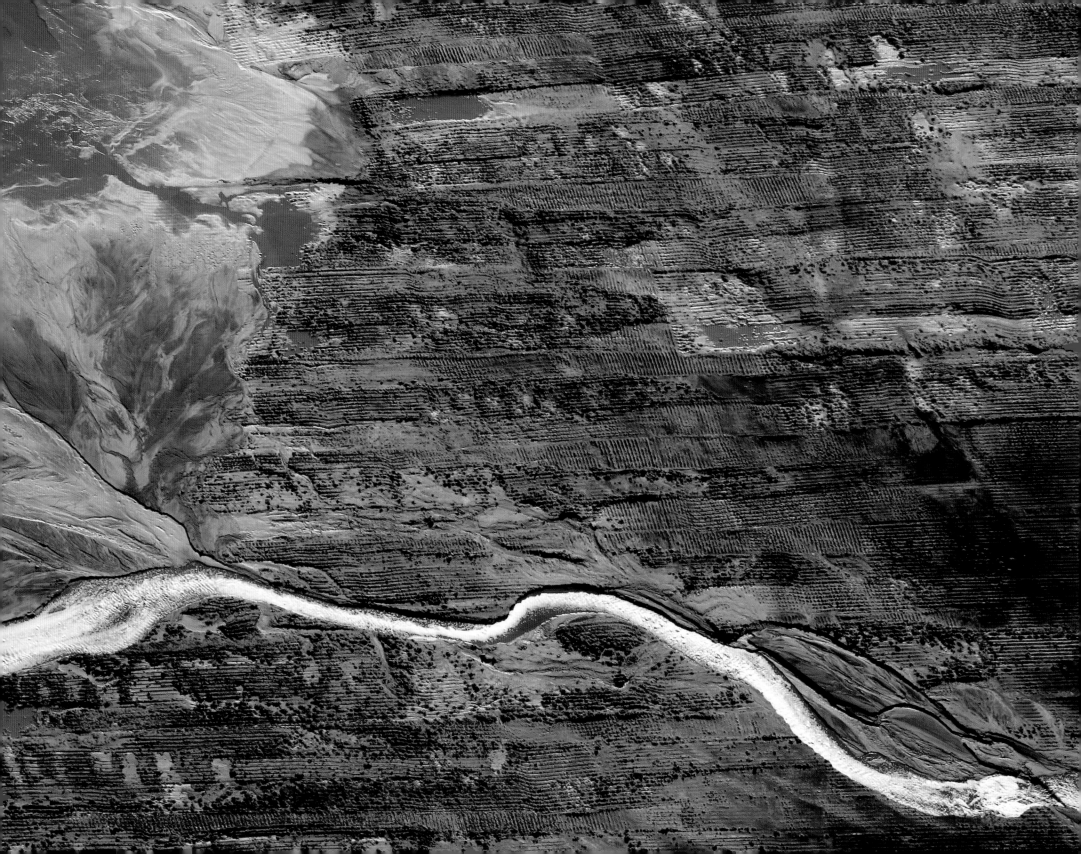

ALL MY EXES LIVE IN TEXAS

Given my growing obsession with our addiction to petroleum, and my conviction that the administration running the country was entirely corrupted by the petrochemical industry, the next logical location for my exploration was Houston, the center of our country's oil industry. According to the Energy Information Agency, 40 percent of the petroleum used in the USA comes through the refineries on the Gulf Coast, and Houston is the other half of that picture. I was convinced that a crisis was imminent.

The Port of Houston proved to be the gold mine I expected, being lined with every manner of refinery and chemical plant imaginable. However, achieving precise composition from a moving plane can be difficult, especially on a windy day. If the necessary angle requires that the plane be perpendicular to the wind, it can be almost impossible, as was the case in trying to photograph the notorious BP Texas City Refinery. This plant, one of the largest in the U.S. and quite old, with a terrible safety record, suffered an explosion in March 2005 that killed 15 people.

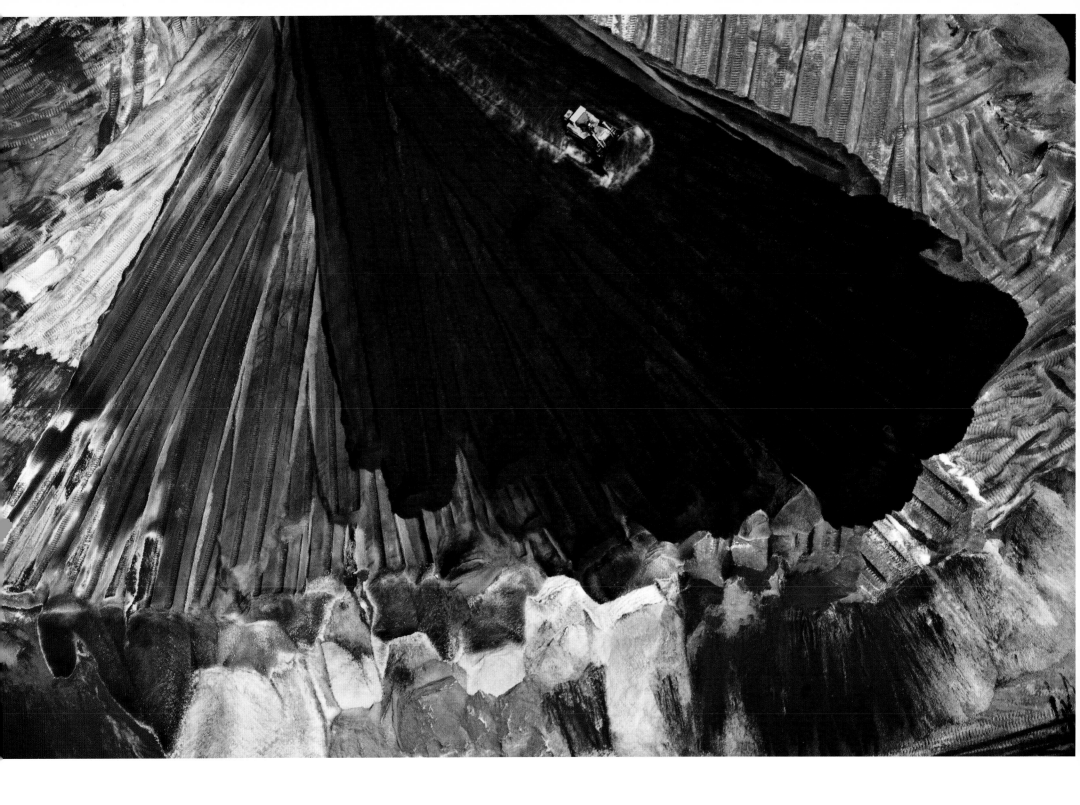

Texas City, Texas.
Petroleum coke is a solid, high-carbon material that is produced as a by-product of the oil refining process. It can serve as either an energy source or carbon source. Fuel-grade petroleum coke is burned to produce energy used in making cement and lime, and for other industrial applications.

Products that utilize petroleum coke as a carbon source include aluminum and steel.

(previous spread and opposite)

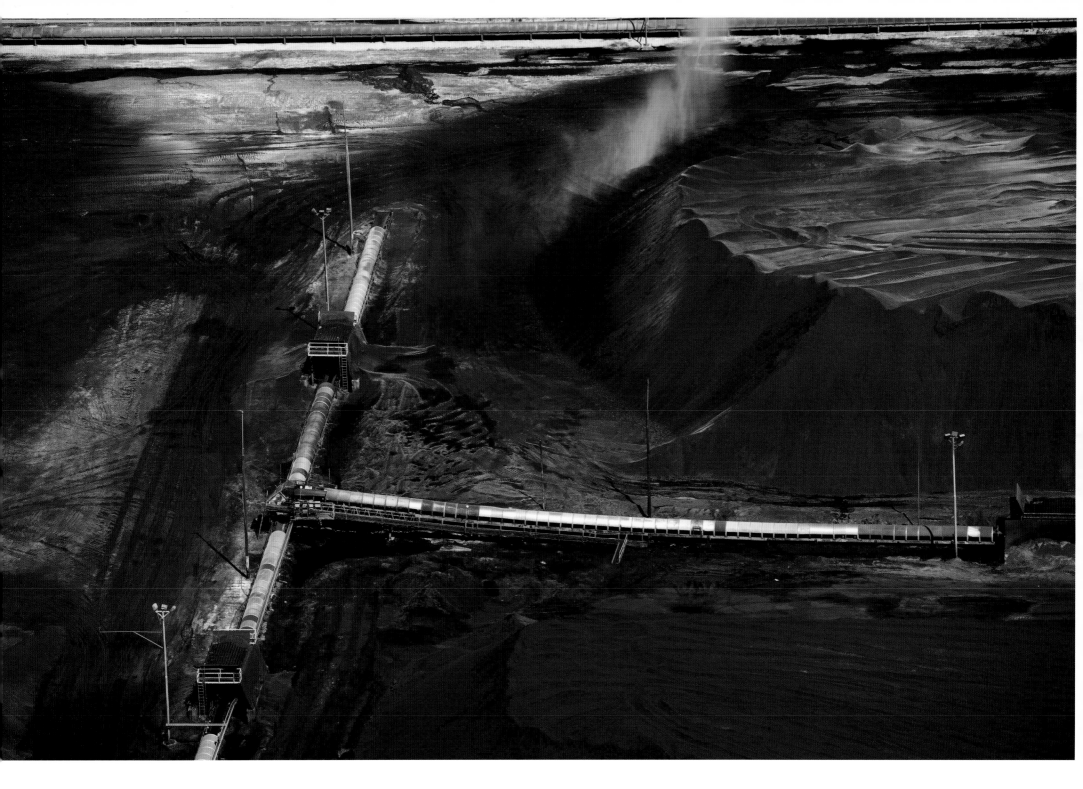

Houston, Texas.
Material dredged from the Houston Ship Channel, which includes all of the toxicants released by the many plants around the harbor, is dumped on this small man-made island.

Lettsworth, Louisiana.
Vehicle tracks in plowed field.

FEEDING THE MASSES

Some of the most interesting subjects in my exploration of the Mississippi River were giant, emerald-green lakes of waste contained by brilliant white dikes. As I flew overhead, I could see giant excavators scooping white material from the bottom of the green lakes and spreading it on the dikes, apparently in order to increase the capacity of the impoundment. Repeated inquiries failed to identify the nature of the mystery, so I resolved to go to the source and ask. After driving around southern Louisiana and stopping people to ask if they knew the location of giant, white mountains, a rather scruffy man in an old pickup truck told me where to look. I found them behind a fence, of course. Gentle queries of the guard (in my best southern accent) added to my understanding, and with further research I discovered I was looking at phosphate fertilizer processing plants.

By the 1800s, after centuries of farming the soil, the productivity of European agriculture was plummeting. The nutrients that plants need to grow had been depleted or washed away, and crop output was declining as population was growing. Increased scientific knowledge was leading to an understanding of the nutritional needs of plants, but the practical approach to providing them was missing. Plants need many nutrients in different varieties, but all need three specific macronutrients: nitrogen, phosphorous, and potassium. Though it had long been known that crushing phosphate rock and spreading it on fields would supply some of the phosphorous needed by the plants, its insolubility in water rendered that method only partially effective. The evolution of a process to synthesize water-soluble phosphoric acid was a critical stage in the agricultural revolution.

Unfortunately, the factories that process phosphate fertilizer are some of the most damaging in the state of Louisiana, and that does not even include pollutants (like uranium waste) that are exempted from reporting. The history of the industry is punctuated with catastrophes and corruption. As the processing plants proliferated, it was noticed that nearby livestock showed a propensity for dropping dead shortly after plant operations commenced. Fluorine gas is a significant byproduct of the fertilizer's synthesis. Not a common topic of most genteel conversation, fluorine is the most potent oxidizer known to man — essentially it corrodes all body tissues. Now the phosphate industry captures it and sells it to the toothpaste manufacturers and municipal water bureaus.

Florida became the next stop in my pilgrimage. A small town called Bartow is the center of the phosphate industry, and like all extraction processes, it dominates the local politics and economy. A quick look at satellite images of the region shows innumerable, large impoundments dotting the landscape. The bulk of our country's phosphate deposits are found in the middle of Florida in a region called Bone Valley, where small sea creatures died and, over the eons, metamorphosed into the material we use to spur the growth of our corn. Here's the rub: we will deplete this reserve in 40 or 50 years at the current rate of consumption, and then the world's remaining reserves will be found principally in Morocco. Talk about a resource crisis.

< Bartow, Florida.
> Lakeland, Florida.
After the trees have been cleared and burned, the phosphate rock excavated and washed, it is then processed with acid to change the insoluble phosphate into phosphoric acid. The process generates five parts waste for one part fertilizer, and concentrates the naturally occurring uranium and radium.

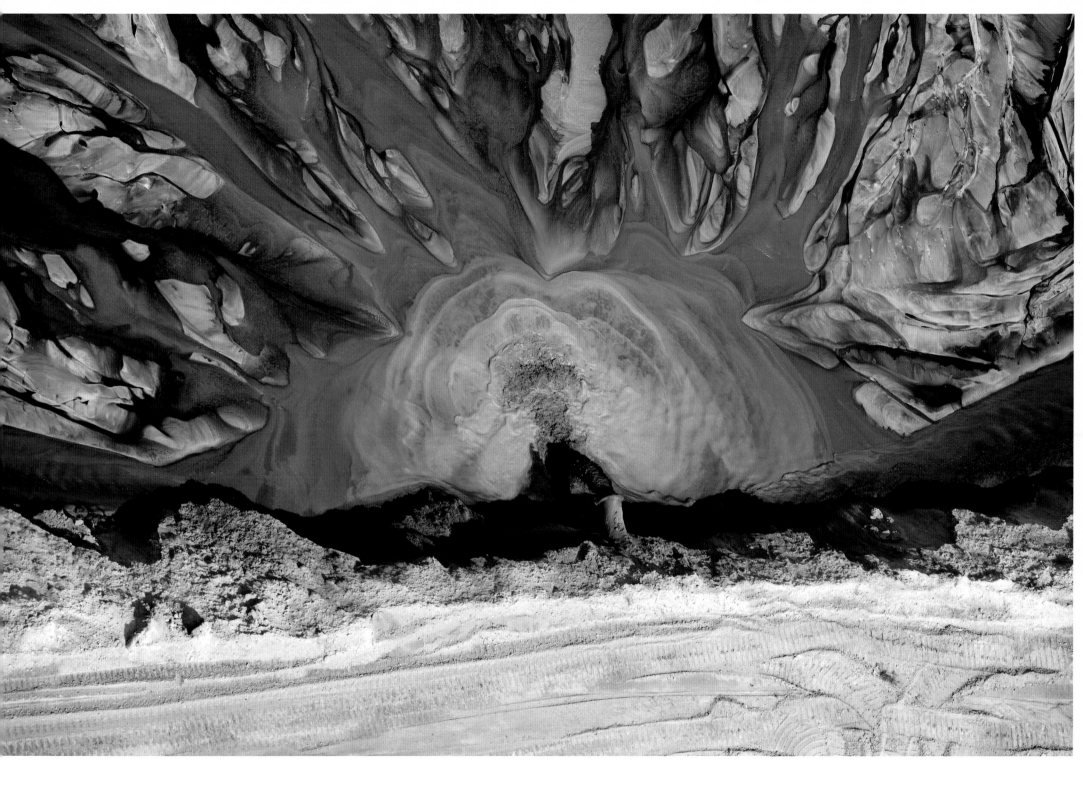

Wauchula, Florida.
The phosphate is washed after extraction, and the by-products are consolidated and pumped out to containment impoundments where the liquids and solids are separated. The green color is presumably algae. The red "barrels" are floats to suspend the hose on top of the liquid.

(opposite page, and page 131)

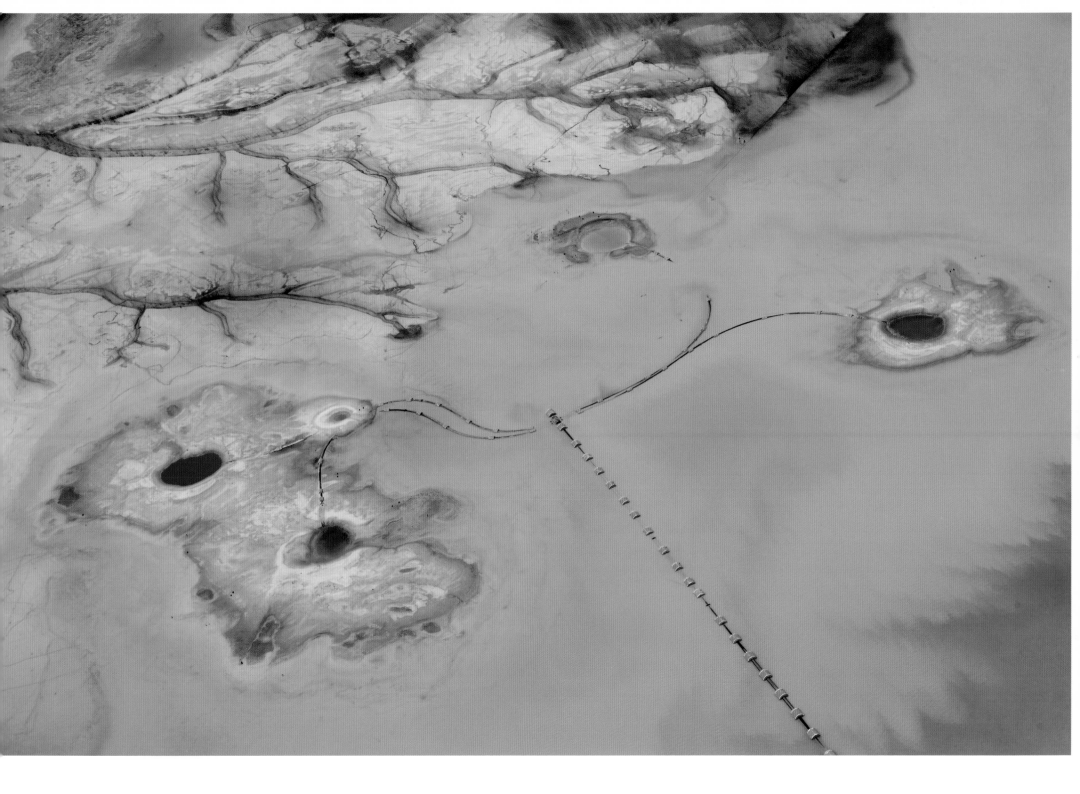

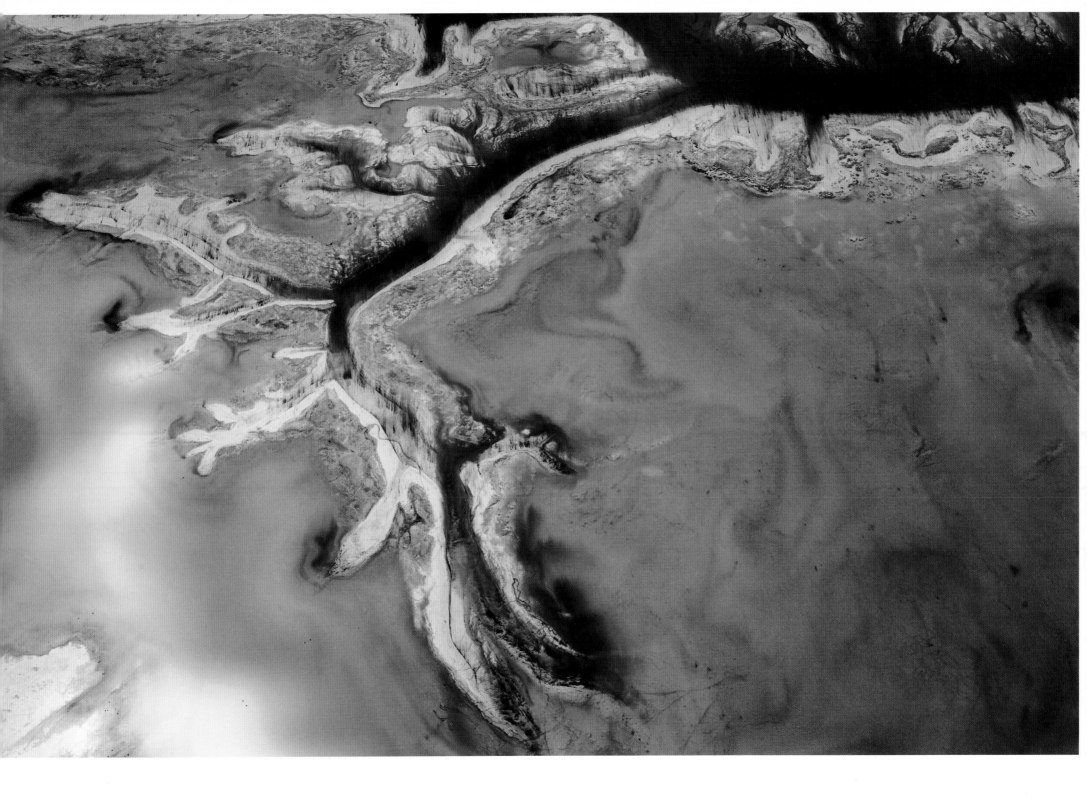

THE ·END?

Contrary to all appearances this is not a book about despair; rather, it is a book about awareness. Many natural treasures have been lost in mankind's struggle for survival, and many more will be lost. For instance, we are already seeing a steep decline in the populations of tigers and polar bears in the wild. In 50 years, will there be any left? These are tragedies that numb the mind. But there is great resiliency in the planetary systems, and if we give them room, they will rebound.

It is very easy for one person to think that her own actions don't matter, but that is precisely the problem. We must never underestimate the power of the individual to create change. One of the most important individual methods for creating the change we seek is to lead by example. If someone hosts a dinner party and serves no meat, explaining that meat causes tremendous water depletion, climate change, and adds to world hunger, the guests will think about it. If the host turns off all the lights and burns beeswax candles, explaining that she is saving the fish in the rivers (and the guests around the table) from mercury poisoning, not to mention all of their children and grandchildren from the perils of climate change, suddenly the actions of one person have a tremendous ripple effect.

Those who bought the first generation of the Toyota Prius supported the advent of a new technology, saved a fortune on gas, and influenced the purchase decisions of those who followed suit, thus saving even more gas from being burned, and more importantly, signaling to the car manufacturers that a market existed for more sustainable technologies. Hydrocarbon fuels will eventually run out and we will be left gasping for breath and scrambling for alternatives if we don't start the transition now.

Whichever country takes the lead on sustainable technologies will own the world. The transition is inevitable; the only question is whether we do it now while we have a comfortable transition period or wait until the "storms of our grandchildren" force an abrupt change. The world awaits America's leadership on these issues. We are the largest per-capita consumers and polluters, and while it's popular to point to the increasing consumption of China and India, our demands drive their own. Meanwhile, China is the nation rushing to develop the new technologies that will power the future, while we happily leave the lights burning and drive around the corner in the SUV for a loaf of processed bread.

Being an adult means taking responsibility for the consequences of your actions. When we act in a way that will ultimately cause distress to our grandchildren, we are not behaving responsibly, even if we convince ourselves that those consequences might not be real. Climate change is the perfect example. Scientists that are not on the payroll of the coal and oil companies concur: the Earth is warming and we are the cause. It is an uncomfortable message, because if we acknowledge it we recognize that we must change our behavior. It is a well-known phenomenon that removing graffiti and litter in a neighborhood reduces crime. Every action matters, both for its actual consequence, but also for its symbolic impact. Every aluminum can you recycle, every roll of post-consumer toilet paper you buy, every time you ride a bicycle rather than drive a car, it has an actual and a virtual impact.

A young girl walks down a beach, picking up starfish that have washed up with the waves and throwing them back into the water. A grown man approaches and questions her actions. She replies that she is returning the starfish to the sea, to which the man retorts, "Look at all of these starfish washed ashore, it doesn't matter if you throw one or two back." As she picks up another and throws it in the water, she says, "It matters to that one."

<u>James Hansen</u> is the nation's leading scientist on climate issues, perhaps best known for bringing global warming to the world's attention in the 1980s, when he first testified before Congress. A member of the National Academy of Sciences, an adjunct professor in the Department of Earth and Environmental Sciences at Columbia University and at Columbia's Earth Institute, and director of the NASA Goddard Institute for Space Studies, he is frequently called to testify before Congress on climate issues. Dr. Hansen's background in both space and earth sciences allows a broad perspective on the status and prospects of our home planet. He has appeared on *60 Minutes*, *ABC News Tonight*, *Anderson Cooper*, *Charlie Rose*; has been interviewed in *The New York Times* and profiled in *The New Yorker*; and has written for the *Boston Globe*, *Nation*, *New York Review of Books*, and *Scientific American*. Dr. Hansen's first book, *Storms of My Grandchildren*, was released in 2009 and paints a devastating picture of the climate crisis, and what will happen should we continue to deny it.

(pages 78-81)

<u>Allen Hershkowitz</u> is a Senior Scientist at NRDC, specializing in issues related to sustainable development, supply chain management, industrial ecology, the paper industry, health risks, solid waste management, recycling, medical waste, and sludge. He coordinates some of the world's most prominent institutional greening initiatives, including the Academy Awards telecast, the GRAMMY Awards, the "Broadway Goes Green" initiative, and the greening of Major League Baseball, the National Basketball Association, and the United States Tennis Association. He's served on the DuPont Corporation's Bio-Based Fuels Life Cycle Assessment Advisory Board, the National Research Council Committee on the Health Effects of Waste Incineration, and the EPA's Science Advisory Board Subcommittee on Sludge Incineration.

(pages 64-65)

<u>Jack Hitt</u> is an American author. He is a contributing editor to *The New York Times Magazine*, *Harper's Magazine*, and *This American Life*. He also frequently appears in places like *Rolling Stone*, *Wired*, and *Outside* magazine. In 1990, he received the Livingston Award for National Coverage. More recently, a piece on the anthropology of white Indians was selected for "Best American Science Writing," and another piece about dying languages appeared in "Best American Travel Writing." Another piece on the existential life of a superfund site was included in 2007 in Ira Glass' *The New Kings of Nonfiction*.

(pages 108-09)

<u>Roger D. Hodge</u> is the author of *The Mendacity of Hope: Barack Obama and the Betrayal of American Liberalism*. Hodge was the editor in chief of *Harper's Magazine* from 2006 to 2010. He joined the staff of *Harper's* in 1996, created the magazine's "Findings" column, as well as the online "Weekly Review," and was a National Magazine Award finalist for Reviews and Criticism in 2006. He lives in Brooklyn, New York, with his wife and their two sons.

(pages 98-99)

<u>Frances Mayes</u> is the author of four books about Tuscany. The now-classic *Under the Tuscan Sun* — which was a *New York Times* bestseller for more than two and a half years and became a Touchstone movie starring Diane Lane — was followed by *Bella Tuscany* and two illustrated books, *In Tuscany* and *Bringing Tuscany Home*. Mayes is also the author of the novel, *Swan*, six books of poetry, most recently *Ex Voto*, and *The Discovery of Poetry*. A frequent contributor to food and travel publications, she divides her time between North Carolina and Cortona, Italy.

(pages 16-17)

<u>John Rockwell</u> is a writer and arts critic. A longtime employee of *The New York Times*, he served as classical music critic, reporter, and editor; chief rock critic; European cultural correspondent; editor of the Sunday Arts & Leisure section; arts columnist; and chief dance critic. He also founded and directed the Lincoln Center Festival for its first four years. A prolific freelancer throughout his career, he has published books on American musical composition, Frank Sinatra, and Lars von Trier, as well as a compilation, and is working on others about *The Magic Flute* and Philip Glass.

(pages 48-49)

<u>Tensie Whelan</u> has held a wide variety of jobs in her career — reporter, editor, consultant, nonprofit executive — with a common theme: passionate activism on behalf of the environment. Whelan, who earned an M.A. from American University's School of International Service and a B.A. from New York University, has been involved with the Rainforest Alliance since 1990, first as a board member and later as a consultant, becoming executive director in 2000 and president in 2007.

(pages 40-41)

I gratefully acknowledge the organizations that have supported my work. I support them and hope you will too.

LightHawk's mission is to champion environmental protection through the unique perspective of flight.
www.lighthawk.org

NRDC's mission is to safeguard the Earth: its people, its plants and animals, and the natural systems on which all life depends.
www.nrdc.org

SouthWings' flights protect and restore Southeastern ecosystems.
www.southwings.org

There are many groups working to save your habitat. Some others that I support are Greenpeace, Open Space Institute, Planned Parenthood, and Riverkeeper.

Waterkeeper Alliance is a global environmental movement uniting more than 190 Waterkeeper organizations around the world and focusing citizen advocacy on the issues that affect our waterways, from pollution to climate change.

The Wolf Conservation Center promotes wolf conservation by teaching about wolves, their relationship to the environment, and the human role in protecting their future.

The Rainforest Alliance works to conserve biodiversity and ensure sustainable livelihoods by transforming land-use practices, business practices, and consumer behavior.

By promoting economic revitalization, environmental protection, and education, Catskill Mountainkeeper serves as a strong advocate for the protection and enhancement of the Catskill Mountains. Through a network of concerned citizens, it works to promote sustainable economic growth and the protection of natural resources essential to healthy communities.

ACKNOWLEDGEMENTS

No endeavor happens without the help of many.

My father is first on the list, for his unwavering support over so many years.
My family in Mobile has provided me with succor in the grueling endeavor of documenting the BP spill.
Allen Hershkowitz of NRDC is one of the great environmentalists of our day, and his support, advice, and guidance over the years has been instrumental in the realization of this project.
Katherine Womer Benjamin gets the train into the station on time.
Rene Perez is a great friend and fantastic editor, with an ability to cut through to the essential elements in a project.

The pilots and staff of SouthWings and LightHawk have been amazing in getting me over these sites. Tom Hutchings on the BP spill, and Bob Keller on Northeast issues have both flown me numerous times, as has Hume Davenport. They and their compatriots are dedicated environmentalists, committed to getting the message out about the rampant, needless damage being done to our habitat. It is an honor to work with them.

And so many thanks to:
Nicolai Burchartz for his constant clarity of vision and keeping me on message.
Heather Flournoy for her social media skills and feeding the community with local food.
Helene Grimaud showed me how to connect to the wild.
Adele Reising introduced me to ancient wisdom and the mind/body/planet equilibrium.
Iris Vogel put me in touch with wind and water.
Ray Vogel taught me humility.
Tensie Whelan showed me the relation of environmental practice and business.

Doug Barasch is a fantastic editor, and stepped in with essential advice at the right time.
Kiki Bauer did a great job with the design, and showed great patience as we wobbled toward the final concept.
Robert Best conceived the icons.
Craig Cohen saw the vision and shepherded the book from idea to tome.
Will Luckman patiently refined the project to completion.
Luke Derivan designed and executed the icons in the appendix.
Willie Fontenot has insight into occulted environmental issues, particularly on the Mississippi River.
Larry Gibson is a modern David, fighting the Goliath of king coal.
EunJin Oh executes my ideas far better than I ever could.
Thomas Arena has worked doggedly to tell the story of coal.

NEUROLOGICAL TOXINS · IMMUNE SYSTEM DISRUPTORS · CARCINOGENS · HABITAT DESTRUCTION · WATER DEPLETION · WATER CONTAMINATION · AIR POLLUTION · RESOURCE DEPLETION · CLIMATE CHANGE

This plant is in the top 10 percent of the dirtiest sites in the USA for airborne releases of carcinogens, and it also puts 3,900 pounds of lead into the environment annually. According to an ombudsman for the Louisiana district attorney, when it went online, the water table in a 50 mile radius dropped.

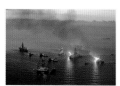

NEUROLOGICAL TOXINS · IMMUNE SYSTEM DISRUPTORS · CARCINOGENS · HABITAT DESTRUCTION · WATER CONTAMINATION · AIR POLLUTION · RESOURCE DEPLETION · CLIMATE CHANGE

This image clearly shows the tremendous volume of visible pollution released in the flaring of captured gas. The loose methane and other volatile gases released from the well that percolate to the surface and into the atmosphere will have a tremendous climate change effect.

NEUROLOGICAL TOXINS · IMMUNE SYSTEM DISRUPTORS · CARCINOGENS · HABITAT DESTRUCTION · WATER CONTAMINATION · AIR POLLUTION · RESOURCE DEPLETION · CLIMATE CHANGE

Barataria Bay is an extensive wetland habitat on the west side of the Mississippi river delta. Current and wind drove oil from the leaking Macondo well westward to Louisiana and up into the estuarial system. Sometimes oil could be seen well into areas that would seem hydrologically isolated. Many brown pelican nests and juveniles could be seen surrounded by oil.

NEUROLOGICAL TOXINS · IMMUNE SYSTEM DISRUPTORS · CARCINOGENS · HABITAT DESTRUCTION · WATER CONTAMINATION · AIR POLLUTION · RESOURCE DEPLETION · CLIMATE CHANGE

Photographing from a low-flying plane requires action without thought. This image of different types of oil mixing is one of my favorites from the project.

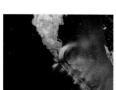

NEUROLOGICAL TOXINS · IMMUNE SYSTEM DISRUPTORS · CARCINOGENS · HABITAT DESTRUCTION · WATER CONTAMINATION · AIR POLLUTION · RESOURCE DEPLETION · CLIMATE CHANGE

Flying over operations in the Gulf, I was struck by the variety of environmental impacts. In the case of the flares, the exhaust gases will have a similar impact to other hydrocarbon combustions.

NEUROLOGICAL TOXINS · IMMUNE SYSTEM DISRUPTORS · CARCINOGENS · HABITAT DESTRUCTION · WATER CONTAMINATION · AIR POLLUTION · RESOURCE DEPLETION · CLIMATE CHANGE

The seeming futility of collecting the floating oil conflicts with the horrible effects of the dispersant sprayed to remove it from public view.

NEUROLOGICAL TOXINS · IMMUNE SYSTEM DISRUPTORS · CARCINOGENS · HABITAT DESTRUCTION · WATER CONTAMINATION · AIR POLLUTION · RESOURCE DEPLETION · CLIMATE CHANGE

There are about 600 unexplained oil spills monthly in the Gulf of Mexico. Oil is a "natural" substance, and the ecosystem can absorb a certain amount of it. The massive quantities that have been dumped in the Gulf overwhelm those systems.

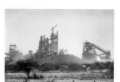

HABITAT DESTRUCTION · WATER DEPLETION · WATER CONTAMINATION · AIR POLLUTION · CLIMATE CHANGE

The tremendous volume of white dust from this plant suggested cement, the production of which produces five percent of global carbon dioxide output, making it a major cause of climate change. Dust produced by a cement plant, especially in less regulated areas, infiltrates every crack and pore of nearby communities causing a plethora of health issues.

HABITAT DESTRUCTION

Garbage is one of the first signs of civilization.

NEUROLOGICAL TOXINS · IMMUNE SYSTEM DISRUPTORS · CARCINOGENS · HABITAT DESTRUCTION · WATER DEPLETION · WATER CONTAMINATION · RESOURCE DEPLETION · CLIMATE CHANGE

Many old petrol stations have leaking storage tanks contaminating the groundwater.

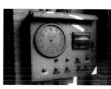

NEUROLOGICAL TOXINS · IMMUNE SYSTEM DISRUPTORS · CARCINOGENS · HABITAT DESTRUCTION · WATER DEPLETION · WATER CONTAMINATION · AIR POLLUTION · CLIMATE CHANGE

Garbage incineration is a process fraught with risk. An exact combination of temperature, time, and turbulence must be used, specific to the material being burned, to minimize the production of deadly toxicants such as dioxin. Many communities are constructing cogeneration facilities to produce electricity from trash, but this is not the "win-win" solution it seems.

NEUROLOGICAL TOXINS | IMMUNE SYSTEM DISRUPTORS | CARCINOGENS | HABITAT DESTRUCTION | WATER DEPLETION | WATER CONTAMINATION | AIR POLLUTION | RESOURCE DEPLETION | CLIMATE CHANGE

This image is assembled from four separate handheld shots taken while panning clockwise. The blue cast is due to the very low light at dusk.

NEUROLOGICAL TOXINS | IMMUNE SYSTEM DISRUPTORS | CARCINOGENS | HABITAT DESTRUCTION | WATER DEPLETION | WATER CONTAMINATION | AIR POLLUTION | RESOURCE DEPLETION | CLIMATE CHANGE

Another significant environmental impact of power plants is the introduction of heat back into the environment. A huge volume of heated water from cooling systems is replaced into rivers and waterways at many power plants, killing a tremendous amount of aquatic wildlife. A cooling tower can help ameliorate this.

NEUROLOGICAL TOXINS | IMMUNE SYSTEM DISRUPTORS | CARCINOGENS | HABITAT DESTRUCTION | WATER DEPLETION | WATER CONTAMINATION | AIR POLLUTION | RESOURCE DEPLETION | CLIMATE CHANGE

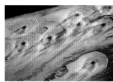

Paper is one of the foundations of human society, enabling documentation, mass communication, and countless conveniences, but, in the words of a Swedish paper mill engineer, it is a luxury society can no longer afford.

NEUROLOGICAL TOXINS | IMMUNE SYSTEM DISRUPTORS | CARCINOGENS | HABITAT DESTRUCTION | WATER DEPLETION | WATER CONTAMINATION | AIR POLLUTION | RESOURCE DEPLETION | CLIMATE CHANGE

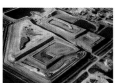

Aerosols and refrigerants are two modern conveniences taken for granted, but with tremendous consequences. This refinery rates very high on an overall score of pollutants, especially toxicants affecting the blood, endocrine systems, kidneys, and nervous system — but the climate change and ozone depleting effects are even more severe.

NEUROLOGICAL TOXINS | IMMUNE SYSTEM DISRUPTORS | CARCINOGENS | HABITAT DESTRUCTION | WATER DEPLETION | WATER CONTAMINATION | AIR POLLUTION | RESOURCE DEPLETION | CLIMATE CHANGE

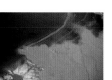

The impacts of aluminum are extensive, disparate, and hard to connect. The footprint extends from deforestation and groundwater pollution in Brazil and Jamaica, to economic collapse in Iceland. Ubiquitous, large, red mud waste pits with caustic leachate and toxic dust plague communities around the world.

NEUROLOGICAL TOXINS | IMMUNE SYSTEM DISRUPTORS | CARCINOGENS | HABITAT DESTRUCTION | WATER DEPLETION | WATER CONTAMINATION | AIR POLLUTION | RESOURCE DEPLETION | CLIMATE CHANGE

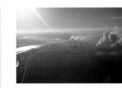

This power plant rates as one of the dirtiest 10 percent of industrial facilities in the USA. Of particular note are the arsenic and mercury released into the groundwater and air, respectively.

NEUROLOGICAL TOXINS | IMMUNE SYSTEM DISRUPTORS | CARCINOGENS | HABITAT DESTRUCTION | WATER DEPLETION | WATER CONTAMINATION | AIR POLLUTION | RESOURCE DEPLETION | CLIMATE CHANGE

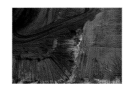

This plant releases almost a pound of dioxin into the air every year, and 891 pounds of mercury.

NEUROLOGICAL TOXINS | IMMUNE SYSTEM DISRUPTORS | CARCINOGENS | HABITAT DESTRUCTION | WATER DEPLETION | WATER CONTAMINATION | AIR POLLUTION | RESOURCE DEPLETION | CLIMATE CHANGE

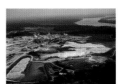

Partial list of air releases (in pounds): developmental toxicants: 380,408; immunotoxicants 143,268; gastrointestinal or liver toxicants 493,772; neurotoxicants 488,166; respiratory toxicants 581,268; skin or sense organ toxicants 580,373.

NEUROLOGICAL TOXINS | IMMUNE SYSTEM DISRUPTORS | CARCINOGENS | HABITAT DESTRUCTION | WATER DEPLETION | WATER CONTAMINATION | AIR POLLUTION | RESOURCE DEPLETION | CLIMATE CHANGE

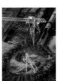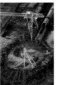

These trees once provided a host of ecosystem services for us, including carbon sequestration, water retention and cleansing, air cleansing, and weather stabilization. Soon they will be ingested by this pulp mill and discharged as paper towels which will be used once and discarded.

NEUROLOGICAL TOXINS | IMMUNE SYSTEM DISRUPTORS | CARCINOGENS | HABITAT DESTRUCTION | WATER DEPLETION | WATER CONTAMINATION | AIR POLLUTION | RESOURCE DEPLETION | CLIMATE CHANGE

Little information about the toxicity of this specific site is available in the public domain (other than hearsay) as it was shuttered years ago.

NEUROLOGICAL TOXINS · IMMUNE SYSTEM DISRUPTORS · CARCINOGENS · HABITAT DESTRUCTION · WATER CONTAMINATION · AIR POLLUTION · RESOURCE DEPLETION · CLIMATE CHANGE

Old industrial sites change over time. The leachate from the red mud waste of aluminum production can exceed pH 13 posing a significant environmental hazard that must be collected and neutralized at tax-payer expense long after the company has left the area.

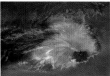

NEUROLOGICAL TOXINS · IMMUNE SYSTEM DISRUPTORS · CARCINOGENS · WATER DEPLETION · WATER CONTAMINATION · AIR POLLUTION · RESOURCE DEPLETION · CLIMATE CHANGE

According to The Container Recycling Institute, "Had the 50.7 billion cans wasted in 2001 been recycled, they could have saved the energy equivalent of 16 million barrels of crude oil — enough energy to generate electricity for 2.7 million U.S. homes for a year."

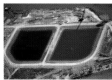

NEUROLOGICAL TOXINS · IMMUNE SYSTEM DISRUPTORS · CARCINOGENS · HABITAT DESTRUCTION · WATER DEPLETION · WATER CONTAMINATION · AIR POLLUTION · RESOURCE DEPLETION · CLIMATE CHANGE

This power plant burns coal and releases 3,301,283 tons of carbon dioxide; 12,299 tons of sulfur dioxide; and 167 pounds of mercury a year.

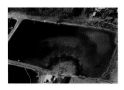

This photo, made at the beginning of the project, is not identified by location; thus, documentation of environmental and human health impacts is not possible.

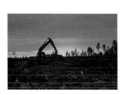

HABITAT DESTRUCTION · WATER DEPLETION · WATER CONTAMINATION · RESOURCE DEPLETION · CLIMATE CHANGE

Much of the carbon released in the process of deforestation comes from the disturbance of the soil, which has a complex biology that has evolved over centuries. The damage done is essentially irreparable, like that done to the visible flora and fauna.

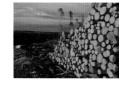

HABITAT DESTRUCTION · WATER DEPLETION · WATER CONTAMINATION · RESOURCE DEPLETION · CLIMATE CHANGE

Twenty-five to 30 percent of the greenhouse gases released into the atmosphere each year, about 1.6 billion tons, is the result of deforestation.

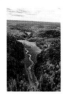

CLIMATE CHANGE

Forests and wetlands clean the air and the water, and provide a wealth of flora and fauna that supply us with a variety of services.

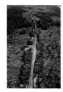

HABITAT DESTRUCTION · WATER DEPLETION · WATER CONTAMINATION · AIR POLLUTION · RESOURCE DEPLETION

Deforestation of boreal forests (in this case to manufacture paper products), releases the tremendous amount of carbon stored in the foliage and soil, eliminates the ability of the system to retain water, causes erosion, and destroys habitat for animals.

 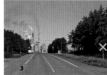

NEUROLOGICAL TOXINS · IMMUNE SYSTEM DISRUPTORS · CARCINOGENS · HABITAT DESTRUCTION · WATER DEPLETION · WATER CONTAMINATION · AIR POLLUTION · RESOURCE DEPLETION · CLIMATE CHANGE

This fox stood on the road long enough to allow access to cameras and photographing. This would seem to indicate disorientation.

NEUROLOGICAL TOXINS · IMMUNE SYSTEM DISRUPTORS · CARCINOGENS · HABITAT DESTRUCTION · WATER DEPLETION · WATER CONTAMINATION · AIR POLLUTION · RESOURCE DEPLETION · CLIMATE CHANGE

This plant was closed in 2006 after a strike in opposition to a 6.4 percent wage cut. The single-industry town lost 650 jobs.

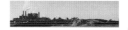

NEUROLOGICAL TOXINS · IMMUNE SYSTEM DISRUPTORS · CARCINOGENS · HABITAT DESTRUCTION · WATER DEPLETION · WATER CONTAMINATION · AIR POLLUTION · RESOURCE DEPLETION · CLIMATE CHANGE

Paper mills are a tremendous source of climate changing gases as well as a host of toxic chemicals released into the air and water.

Years later, instead of the ecosystem regeneration promised by the mining companies, the devastation at these sites spreads into the surrounding forests like cancer, causing them to wither.

The business of coal is incomprehensible: that profits can be so high in spite of the staggering waste and environmental destruction.

The final insult caused by mountaintop removal mining: this grass seed being sprayed is non-native, and the fertilizer will run off and contaminate watercourses.

Eight hundred square miles or more of America's most precious forests have been destroyed by mountaintop removal mining.

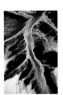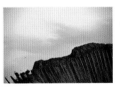

Coal slurry impoundments are unlined and contain large quantities of lead, mercury, arsenic, chromium, copper, and a host of other toxicants that leach out and contaminate groundwater.

The forests of Appalachia are the most biodiverse in North America. Since 1992, MTR has destroyed seven percent of these old-growth forests.

The most recent coal slurry impoundment failure, in 2000, released 300 million gallons of toxic waste into the Big Sandy River killing all aquatic life for 70 miles downstream.

Three and a half million pounds of ammonium nitrate are used in West Virginia per day to destroy some of the most valuable forests and mountains in the USA. As a comparison, a little over 5,000 pounds were used in the Oklahoma City bombing.

Mining operations work around the clock at an amazing speed. This lonely stand of trees disappeared in barely a day. The small bulldozer on the upper level pushes loose material down to the loader, which scoops it up into the next earth-mover in line, which will dump it into a nearby "valley fill," burying the stream there.

This company is known to have destroyed world heritage sites in Indonesia, poisoned the water supply of native peoples with its mining practices, and is rumored to be an instigator in the Bay of Pigs invasion.

NEUROLOGICAL TOXINS IMMUNE SYSTEM DISRUPTORS CARCINOGENS HABITAT DESTRUCTION WATER DEPLETION WATER CONTAMINATION AIR POLLUTION RESOURCE DEPLETION CLIMATE CHANGE

327,676 pounds of lead a year are dumped into these open impoundments to be blown as dust into the predominantly poor neighborhoods that surround the facility.

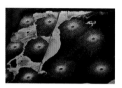

HABITAT DESTRUCTION WATER DEPLETION WATER CONTAMINATION AIR POLLUTION RESOURCE DEPLETION CLIMATE CHANGE

Sugar has a tremendous deleterious effect on the environments where it is grown, as wetlands are drained and filled for its cultivation, then polluted by the fertilizer and pesticide runoff, then pumped dry of water used for irrigation.

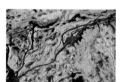

NEUROLOGICAL TOXINS IMMUNE SYSTEM DISRUPTORS CARCINOGENS HABITAT DESTRUCTION WATER DEPLETION WATER CONTAMINATION AIR POLLUTION RESOURCE DEPLETION CLIMATE CHANGE

Because of the exemptions in the Clean Air and Clean Water Acts, which specifically exempt fertilizer manufacturers, there is no way to know the actual pollution created by this facility. The contaminants it does report prove it to be one of the most polluting in the USA.

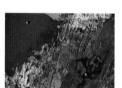

NEUROLOGICAL TOXINS IMMUNE SYSTEM DISRUPTORS CARCINOGENS WATER DEPLETION WATER CONTAMINATION AIR POLLUTION RESOURCE DEPLETION CLIMATE CHANGE

This plant creates 830,000 pounds of respiratory toxicants, 798,000 pounds of skin toxicants, 256,000 pounds of neurotoxicants, and 574,000 pounds of musculoskeletal toxicants a year.

NEUROLOGICAL TOXINS IMMUNE SYSTEM DISRUPTORS CARCINOGENS WATER DEPLETION WATER CONTAMINATION AIR POLLUTION RESOURCE DEPLETION CLIMATE CHANGE

These are waste impoundments from the manufacture of HCFCs, a class of chemical with many industrial and consumer applications. They are primarily used as propellants and refrigerants and find their way into cooling coils and spray cans.

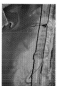

NEUROLOGICAL TOXINS IMMUNE SYSTEM DISRUPTORS CARCINOGENS WATER DEPLETION WATER CONTAMINATION AIR POLLUTION RESOURCE DEPLETION CLIMATE CHANGE

Environmental Investigation Agency, an environmental watchdog, says that HFCs are up to 12,500 times as potent as carbon dioxide in global warming.

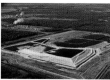

NEUROLOGICAL TOXINS IMMUNE SYSTEM DISRUPTORS CARCINOGENS HABITAT DESTRUCTION WATER DEPLETION WATER CONTAMINATION AIR POLLUTION RESOURCE DEPLETION CLIMATE CHANGE

The density of the phosphogypsum waste material is quite high, and the volume tremendous, pushing the limit of the load-bearing capacity of the ground below. In several instances of engineering miscalculation, the ground has collapsed, allowing the toxic combination of acids, heavy metals, and other contaminates to collapse into the aquifer below.

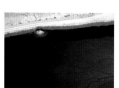

NEUROLOGICAL TOXINS IMMUNE SYSTEM DISRUPTORS CARCINOGENS HABITAT DESTRUCTION WATER DEPLETION WATER CONTAMINATION AIR POLLUTION RESOURCE DEPLETION CLIMATE CHANGE

This facility produces 600,000 pounds of neurotoxicants, 560,000 pounds of reproductive toxicants, 750,000 pounds of respiratory toxicants and 750,000 pounds of skin toxicants a year.

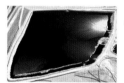

NEUROLOGICAL TOXINS IMMUNE SYSTEM DISRUPTORS CARCINOGENS HABITAT DESTRUCTION WATER DEPLETION WATER CONTAMINATION AIR POLLUTION RESOURCE DEPLETION CLIMATE CHANGE

The radioactive particles from the waste at this facility will become airborne as dust and disperse throughout the community, being inhaled by the population, settling onto agricultural fields and into waterways.

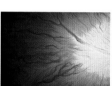

NEUROLOGICAL TOXINS IMMUNE SYSTEM DISRUPTORS CARCINOGENS HABITAT DESTRUCTION WATER DEPLETION WATER CONTAMINATION AIR POLLUTION RESOURCE DEPLETION CLIMATE CHANGE

When the price of uranium is high enough, this facility can extract large quantities from its waste, for sale to the nuclear industry.

NEUROLOGICAL TOXINS IMMUNE SYSTEM DISRUPTORS CARCINOGENS WATER DEPLETION WATER CONTAMINATION AIR POLLUTION RESOURCE DEPLETION CLIMATE CHANGE

Between 1990 and 2000, Americans wasted a total of 7.1 million tons of cans, enough to manufacture 316,000 Boeing 737 airplanes — or enough to reproduce the world's entire commercial air fleet 25 times.

NEUROLOGICAL TOXINS IMMUNE SYSTEM DISRUPTORS CARCINOGENS WATER DEPLETION WATER CONTAMINATION AIR POLLUTION RESOURCE DEPLETION CLIMATE CHANGE

Residue from an aluminum oxide refinery pools, dries, and cracks. Red indicates iron oxide; white shows aluminum oxide and sodium bicarbonate. Tremendous amounts of red mud bauxite waste are created in the production of aluminum, which also contains other contaminants, heavy metals, and impurities.

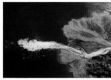

NEUROLOGICAL TOXINS · IMMUNE SYSTEM DISRUPTORS · CARCINOGENS · WATER DEPLETION · WATER CONTAMINATION · AIR POLLUTION · RESOURCE DEPLETION · CLIMATE CHANGE

Aluminum smelting produces a quantity of fluoride waste; perfluoro-carbons and hydrogen fluoride which are both locally toxic and potent greenhouse gases.

HABITAT DESTRUCTION · WATER DEPLETION · WATER CONTAMINATION · AIR POLLUTION · RESOURCE DEPLETION · CLIMATE CHANGE

Industrial agriculture is geared to the plowing of fields, which great-ly increases runoff, and the application of fertilizers, which are a tremendous pollutant. Fertilizers pollute throughout their production cycle, again when they are applied, and finally after washing away. In its final destination in downstream water bodies, fertilizer promotes algal growth and death, causing hypoxia and stagnation.

NEUROLOGICAL TOXINS · IMMUNE SYSTEM DISRUPTORS · CARCINOGENS · WATER DEPLETION · WATER CONTAMINATION · AIR POLLUTION · RESOURCE DEPLETION · CLIMATE CHANGE

Petroleum coke represents that final stage in the life cycle of petro-leum, and it even then it remains useful.

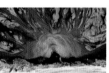

NEUROLOGICAL TOXINS · IMMUNE SYSTEM DISRUPTORS · CARCINOGENS · HABITAT DESTRUCTION · WATER DEPLETION · WATER CONTAMINATION · AIR POLLUTION · RESOURCE DEPLETION · CLIMATE CHANGE

This waste liquid from the processing of raw phosphate with sulfuric acid is radioactive and acidic, and was clearly mixing with surface water, thus groundwater.

NEUROLOGICAL TOXINS · IMMUNE SYSTEM DISRUPTORS · CARCINOGENS · WATER DEPLETION · WATER CONTAMINATION · AIR POLLUTION · RESOURCE DEPLETION · CLIMATE CHANGE

This "pet coke" facility is adjacent to numerous refineries at the en-trance to the Houston Ship Channel.

NEUROLOGICAL TOXINS · IMMUNE SYSTEM DISRUPTORS · CARCINOGENS · HABITAT DESTRUCTION · WATER DEPLETION · WATER CONTAMINATION · AIR POLLUTION · RESOURCE DEPLETION · CLIMATE CHANGE

This outlet pipe is at the bottom of a giant waste impoundment in Florida, and forms a stream that eventually joins the water table.

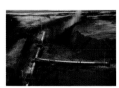

NEUROLOGICAL TOXINS · IMMUNE SYSTEM DISRUPTORS · CARCINOGENS · WATER DEPLETION · WATER CONTAMINATION · AIR POLLUTION · RESOURCE DEPLETION · CLIMATE CHANGE

The rainbow refraction from the escaping liquid was only visible from a certain angle, but the stiff wind made positioning the plane difficult, requiring many circles around the site.

HABITAT DESTRUCTION · WATER DEPLETION · WATER CONTAMINATION · AIR POLLUTION · RESOURCE DEPLETION · CLIMATE CHANGE

Phosphate rock contains uranium. There are epidemiological studies (reported by *US News and World Report*), that indicate lung cancer rates for nonsmoking men in the phosphate regions of Florida are twice the state average, with similar rates of leukemia occurrence.

HABITAT DESTRUCTION · WATER CONTAMINATION · AIR POLLUTION

A recently issued study by the University of Texas suggests that chil-dren living within two miles of the Houston Ship Channel are 56 percent more likely to contract leukemia than the national average.

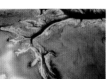

HABITAT DESTRUCTION · WATER DEPLETION · WATER CONTAMINATION · AIR POLLUTION · RESOURCE DEPLETION · CLIMATE CHANGE

Phosphate mining begins with the deforestation and burning of the mined area, then massive water depletion, as the raw material is washed and processed.

the day after tomorrow
images of our earth in crisis

Compilation & Editing © 2010 powerHouse Cultural Entertainment, Inc.
Photographs and texts © 2010 J Henry Fair
Essays © 2010 James Hansen, Allen Hershkowitz, Jack Hitt, Roger D. Hodge, Frances Mayes,
John Rockwell, Tensie Whelan

Published in the United States by powerHouse Books,
a division of powerHouse Cultural Entertainment, Inc.
37 Main Street, Brooklyn, NY 11201-1021
telephone 212 604 9074, fax 212 366 5247
e-mail: dayaftertomorrow@powerHouseBooks.com
website: www.powerHouseBooks.com

www.industrialscars.com
kb@jhenryfair.com

First edition, 2010

Library of Congress Control Number: 2010936242

Hardcover ISBN 978-1-57687-560-5

Book design by Kiki Bauer
Icon design by Luke Derivan

Printed in China by Everbest Printing Company through Four Color Imports, KY

A complete catalog of powerHouse Books and Limited Editions is available upon request;
please call, write, or visit our website.

10 9 8 7 6 5 4 3 2 1